DEDHAM

DEDHAM

HISTORIC AND HEROIC TALES FROM SHIRETOWN

JAMES L. PARR

THE
History
PRESS

Published by The History Press
Charleston, SC 29403
www.historypress.net

First published 2009

Manufactured in the United States

ISBN 978.1.59629.750.0

Library of Congress Cataloging-in-Publication Data

Parr, James, 1959-
Dedham : historic and heroic tales from shiretown / James L. Parr.
p. cm.
Includes bibliographical references and index.
ISBN 978-1-59629-750-0
1. Dedham (Mass.)--History. I. Title.
F74.D3P37 2009
974.4'7--dc22
2009037774

CONTENTS

PREFACE

On an early Tuesday evening in June 1953, residents across Dedham began discovering odd bits of debris in their yards and driveways. Roofing shingles, bits of clapboard siding with bent nails still inside, letters, parts of books, even a raincoat tangled in the branches of a tree all appeared rather suddenly in neighborhoods across town. All of the items had some connection to the city of Worcester: a torn page from the *Worcester Telegram*, a check from a Worcester bank in the amount of $20.67, stationery and bills from Worcester companies. As puzzled residents began to talk to one another and listen to the news broadcasts that evening, they soon learned the cause of all this unusual trash suddenly appearing in Dedham. A powerful tornado had ripped through the Worcester area, carrying the odd collection of debris some forty miles in the air before depositing it in Dedham.

The tales in this book are in some ways like those odd, random bits of debris, carried here from the faraway past. Ripped from its place of origin, the ordinary becomes the unusual; tales of everyday life and customs of Dedhamites from long ago fascinate the modern reader. And, of course, events that were remarkable to the people who first witnessed them remain so to this day.

These tales represent over 350 years of Dedham's past. It is *a* history of the town, not *the* history. That task was undertaken at various times by Herman Mann, Erastus Worthington, Frank Smith and Robert Hanson. Some of the tales in these pages also appeared in those pages, often as footnotes. The stories are presented thematically, and if there seems to be an

overabundance of tales of crime and punishment, that is because Dedham, as county seat or "shire town" of Norfolk County, has hosted hundreds of criminal trials since 1793. The town has also produced its share of heroes, and their stories are presented here as well.

ACKNOWLEDGEMENTS

I would like to thank the following individuals for their help in researching these Shiretown tales: Ron Frazier, Eleanor Palma and Sandra Waxman of the Dedham Historical Society; Dr. Alex Service of the Fairbanks House; Paul Harvey of the Dedham Public Library; Mike Thomas of the Animal Rescue League; Carolyn Strom Collins; Jim Dubois of Framingham High School; Len Travers of UMass Dartmouth; Walter Timilty, Norfolk County clerk of courts; and Barbara F. Berenson of the Massachusetts Supreme Judicial Court. For continually supporting my various projects, I thank my family and friends, especially my mother, Kathleen, Dedham resident for over fifty years. I would also like to acknowledge three particular educators who not only encouraged me to imagine and explore but also gave me the necessary skills that have enabled me to share the results of my explorations: Gregory Ciardi from St. Mary's School and Martin Walsh and Joyce (Lindmark) Fishman from Dedham High School. Finally, thanks to my classmate, friend and fellow storyteller James V. Horrigan, who first shared many of these tales with me and inspired and informed me throughout the entire process.

Chapter One

CONTENTMENT

Anyone who takes the time to carefully inspect the Dedham town seal in its prominent position on the side of the police station or on the door of a passing DPW truck will find at the bottom a banner containing a single word: "Contentment." One might be led to believe that the word was chosen as a motto for the town—an emotional state to strive for while living and working in the factories and fields also pictured on the seal. *Contentment* is actually the name chosen by the original settlers in 1635 when the Massachusetts General Court issued a land grant for the new town. The name did not appeal to the Puritan authorities in Boston, however, and for reasons unknown, when the town was incorporated in 1636 they chose the name Dedham, after the town of the same name in Essex County, England. (The Dedham name was agreeable enough to two later residents who applied it to their new homes in Dedham, Maine, in 1810, and Dedham, Iowa, in 1882.)

That first group of settlers coming from crowded Watertown found much to be content about within the boundaries of the original grant, which included the present-day towns of Natick, Wellesley, Needham, Dover, Westwood, Norwood, Walpole, Medfield, Millis, Medway, Norfolk, Franklin, Bellingham, Wrentham and Plainville. There was a generous water supply as well as meadows that could be cultivated easily. Acres of woodland were available for construction of homes and fuel for fireplaces.

But there were dangers, both real and imagined, in the surrounding forests and swampland, as evidenced in the names given to various natural features by the earliest settlers: Dismal Swamp, Purgatory Brook, Satan's Kingdom

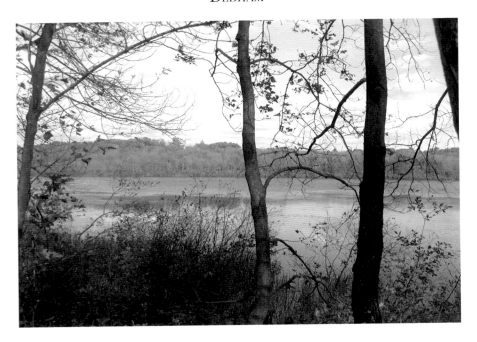

Wigwam Pond. *Photo by author.*

and Devil's Oven. The swamp bordering Wigwam Pond was an especially wild place, inhabited by both wolves and wildcats. In March 1639, seven-year-old John Dwight disappeared one day while playing near his home; he was believed to have been devoured by wolves. Wolves were so abundant that a bounty on their heads was frequently paid. Town ordinances were also passed authorizing bounties on wildcats and rattlesnakes. A 1719 ordinance called for a bounty of six pence to be rewarded for every rattlesnake killed, with proof to be provided in the form of the rattle and an inch and a half of snake. As late as 1759, there were bear sightings near town.

Incredibly, town officials paid out a bounty several hundred years after it was first established. In November 1957, Joseph Demling of Macomber Terrace walked into the Dedham Town Hall seeking a reward for the thirty-five-pound carcass of a bobcat that he was carrying. Macomber shot the animal after his dog had trapped it in a tree. Startled town treasurer Andrew Galvin did not know what to make of the situation, and he conferred with other town officials on how to handle the young man's claim. At first they tried to pass the buck by suggesting that the bobcat had probably come from Needham, and therefore Needham should pay the bounty. In the end, the ancient statute from 1734 was found and cited, setting the bounty of twenty

shillings per wildcat killed. After satisfying himself that the animal was in fact a bobcat and not a treasured family pet, Galvin paid Demling the ten-dollar bounty he had requested.

The Legend of Wigwam Pond

One particular place of foreboding is Wigwam Pond (pronounced "**wigg-**um" by locals), a large kettle pond located near the center of town just to the east of modern Route 1. Despite its central location adjacent to a busy commercial highway, access to the pond is difficult, and most residents of town have never set foot on its shores. But generations of youngsters have been warned away from the pond's entangling weeds, quicksand bottom and restless ghosts.

The "legend" of Wigwam Pond was first told by local writer William Moore. Moore claimed that the legend was first told to him by "the Captain," a Dedham veteran of the Civil War who moved to Cape Cod in his sunset years. That Mr. Moore was a regular contributor of poems and fiction to the *Dedham Transcript* suggests that, like Washington Irving's fictional storyteller Deidrich Knickerbocker, who brought us *The Legend of Sleepy Hollow*, both the Captain and his tale were sprung from the imagination of the prolific writer. Regardless, rumors and tales of eerie happenings and ghostly sounds have been related by residents living near the pond for years. What follows is a summary of the Captain's tale, as written by Moore for a 1932 column in the *Transcript*.

By 1775, there were no natives left in or around Dedham, but there was a small band of Neponsets still living in the woods near Big Blue in present-day Canton. One of these natives was a descendant of King Philip named Black Bear. Black Bear was well known to area residents for his acts of petty thievery against local farmers, including Sam Stone. Stone lived with his family on a farmstead about a mile southwest of Wigwam Pond.

One summer afternoon shortly after the battles at Lexington and Concord, Sam caught the wily Black Bear prowling around the Stone property. The Indian was carrying a musket and several horse blankets he had stolen. Sam Stone would have none of that, and he quickly and decidedly wrestled with the young Indian, who ran away from the farm empty-handed. Black Bear made his way through the swamp to the shores of Wigwam Pond, where his canoe was waiting. After sunset, he returned to the Stone farm, seeking

revenge. While creeping past an open window of the farmhouse, Black Bear spied Stone's infant son sleeping unattended, and he reached through the window and grabbed him. The baby became disturbed and woke up with a cry, alerting his father. Stone chased after the Indian, who abandoned the baby in order to make his escape to Wigwam Pond.

Arriving at the shore, Black Bear quickly jumped in his canoe and began paddling away from the angry farmer. About midway across the pond, the Indian eased up his paddling, believing that he was safe. But Sam Stone had other ideas. He raised his musket to his shoulder and fired, striking the Indian in the back. Mortally wounded, Black Bear stood up in the canoe, gave out a plaintive cry of pain and despair and tipped out of the boat, sinking to the bottom.

Eerie howls and mournful cries have been heard coming from the pond ever since, and generations of residents and workers in the area have often shared tales of the restless spirit that haunts the inhospitable swamp and lake. Workers harvesting ice from the pond knew to stay away from the one area that never froze, even in the coldest of winters, for this was the same spot where Black Bear had met his end so long ago. From time to time, the curious and the brave would venture to the pond at night and catch a glimpse of the ghost of Black Bear running above the surface of the pond, sometimes carrying a small child, sometimes covered by a large horse blanket, but always wailing an unearthly cry. Some may dismiss such stories as hokum and superstition, but it is true that the skeleton of a man was found hanging from a tree in the Wigwam woods in 1920, and another was unearthed by workers digging a house foundation east of the pond in 1923.

Notable Trees

The spread of farmsteads means the inevitable destruction of the surrounding forest, and in time the once thick woodland near the town's center was replaced by a patchwork of stone-walled fields. Some ancient trees survived, however, due in large part to their mammoth size, peculiar appearance or remote location. These trees became familiar landmarks to the residents, and in time many traditions and legends became associated with them.

A large hemlock that stood for many years in West Dedham (now Westwood) was known as Moll Pitcher's tree, after a fortuneteller and witch from Lynn who was immortalized in verse in 1832 by Haverhill poet John

Greenleaf Whittier. It was said that Moll often visited West Dedham and favored the shade beneath the towering tree as a resting spot as she made her way to catch the stage back home. One unseasonably hot spring day, the old woman happened by some men working on a home on Nahatan Street. She asked one of the workmen if she might have a sip of his cider to quench her thirst as she labored up the street. He refused, and with that, the old crone angrily broke her clay pipe in two and told the startled worker that his neck would snap in the same way. Not long after that, the unfortunate man fell from a roof and broke his neck! Moll also cursed the home on which the men had been working, declaring that all who dwelled within would experience bad luck and the house itself would burn down, which it did, many years later.

Another beloved West Dedham tree was the ancient oak that stood in the town pound on High Street. The pound had been erected in 1711 for the purpose of holding stray farm animals such as cattle and swine. When West Dedham (also known as the Clapboard Trees Parish) was incorporated into the new town of Westwood, the pound fell within its boundaries. The Westwood town seal features both the pound and the tree. The tree was blown over in the Hurricane of 1938.

For many years, a large buttonwood tree stood at the corner of Church and High Streets in front of the building that was not only Jeremiah Shuttleworth's

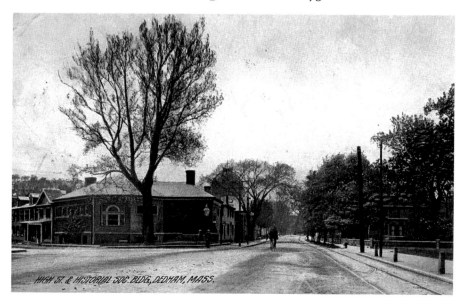

High Street with the historical society and old buttonwood tree. *Author's collection.*

home, but also a grocery store and the town's post office. The heavy foot traffic in and out of the post office made the tree a perfect bulletin board in front of which citizens would congregate to read the many announcements, ads and notices tacked there. Tradition holds that the first notice posted was a fifty-dollar reward for the return of a stolen horse. It was here that many townspeople first read the tragic news of President Lincoln's assassination in April 1865. The buttonwood tree was also a perfect spot to hang someone in effigy. At the start of the Civil War, a young recruit working as a barber in town had the audacity to lift an umbrella over his head when it started to sprinkle during a training session on the common. This display of foppishness did not sit well with either the company of recruits or the commanding officer, Captain Onion, who told the man to put down the umbrella or leave. He left, and a few days later the effigy was hanging from the buttonwood tree bearing a sign that read "the man with the umbrella." Soon thereafter, the "barber dude," as he had come to be known, left town altogether.

After the Dedham Historical Society headquarters and museum was built on the site of the Shuttleworth home in 1886, members discouraged the use of the tree as a message board, with little luck. Eventually, the tradition died out, and dozens of tacks that had accumulated on the trunk were absorbed by the tree's growth. In September 1985, Hurricane Gloria swept through town, knocking down the centuries-old buttonwood tree.

The best-known of all the landmark trees in Dedham was a white oak, already ancient when the first settlers arrived. The tree stood on land once owned by the Avery family, and in time it became known as the Avery Oak. The story has often been told that in 1794, the United States Navy offered seventy dollars to Jonathan Avery to buy the tree and use its timber in the construction of the ship USS *Constitution*. Mrs. Avery, however, protested that the tree should remain where it had stood for so many generations, and so the oak did not become a part of "Old Ironsides."

The tree and a small portion of land surrounding it were deeded to the historical society in 1886. Joseph W. Clark, then owner of the house and property on East Street where the tree stood, deeded to the society the tree and a rectangle of land extending seven and a half feet from the center of the tree on three sides (East Street bordered the oak tree on the fourth side). The deed also stipulated "the perpetual right to allow the branches of said tree to extend over my adjoining land, and the roots thereof, so far as necessary to the life of the tree, to extend in my adjoining land."

The great New England hurricane of September 1938 took down over 450 trees in the town's forest and cemeteries alone, but the Avery Oak survived,

The Avery Oak. *Author's collection.*

although a large limb was torn loose from its upper reaches. On a Tuesday afternoon in late July 1972, Police Chief Walter Carroll was driving along East Street during a violent summer thunderstorm when a huge gust caused the ancient oak to topple, barely missing the chief's cruiser. Hundreds of townspeople made their way to the site to satisfy their curiosity and to pay their last respects to the ancient oak. Dedham Police stood guard over the remains until the historical society could decide what to do with the massive wreckage. When it finally came down, it was estimated that the tree was about 450 years old. Its circumference was measured at twenty feet. Pieces of the tree remain in the form of a chair commissioned by historical society president Henry Hildreth and a gavel given to the chairperson of the board of selectmen after the tree fell. The Avery Oak has been honored on the town seal since it was first adopted in 1878.

The legacy of these fabled trees can serve to inspire new generations with their longevity, stature and beauty. Perhaps a more practical lesson on the nature of trees was learned by the subjects of this news item from the *Village Register* of January 8, 1749:

Dedham, May 15. On Tuesday last, Mr. Joseph Kingsberry of this Place with his Brother, cut down a Tree of considerable bigness, which contrary to their Expectation fell quite a different Course, the Top of which Took him and prest him almost into the Ground, dislocated his Shoulder, broke his Arms, and shivered the Bone to pieces, and bruis'd his body in a most surprising Manner, so that his Life for some Time was almost dispair'd of; but thro' Goodness of God is at present under hopeful Circumstances of Recovery.

Rivers and Rocks

After subduing the forests in the area, the settlers turned their eyes to the river, not to tame it but to invigorate it and use its power for commercial interests. The Charles River had already been mapped and named by the time Dedham's first settlers took up residence near its banks in 1636. It was by this river that the first group of settlers arrived from Watertown, landing at a spot near the modern Ames Street Bridge. This landing spot, known as "the Keye," was commemorated in 1927 with a stone bench and plaque.

While the river provided a safe means of travel and easily obtainable source of food, the meandering corkscrew path it took through the Dedham plain did not produce a flow strong enough to turn a mill wheel. The enterprising colonists resolved this problem in 1639 by constructing the first canal in North America, linking the Charles with the Neponset River some three miles away. The new waterway, called Mother Brook, became an important source of water power for the mills that sprang up along its banks, beginning with a corn mill in 1641 and followed by others producing cotton, paper, nails, wire and leather. Having successfully completed this first engineering feat, the ambitious residents took on another construction project a few miles away in the northeast section of town. Here a loop in the Charles nearly made an island. In 1654, town officials proposed to cut a ditch from one section of the loop to another, a distance of over four thousand feet. This ditch would not only create a shortcut for boaters, but it would also relieve the spring flooding that often occurred in the "Broad meadow." The construction of "the long ditch" completed the job that the Charles could not, creating an island in the section of town known today as Riverdale. The long ditch connects to the Charles at the bridge on Dedham Street near the Needham border.

Contentment

While the Charles could not provide water power for the town's manufacturers, over the years it has proven to be a popular source of recreation for young and old. Diving into the murky river may not seem appealing to a swimmer of today, but up until the middle of the last century, the Charles was the best swimming hole in town. For years, the Community House offered lessons at "Cox's Cove," and hundreds of sunbathers and swimmers crowded the riverbank at Riverdale Park on hot summer days. Beaches and bathhouses were built on Mother Brook as well. Skating, boating and fishing were also popular activities undertaken on the river. Pollution put an end to many of these pursuits, but in recent years the river has become cleaner, and canoeists and kayakers continue to enjoy the serenity found along its picturesque course.

In West Dedham, there once stood a large rock formation with a small opening at the bottom that formed a cave. It was known as Indian Oven or Devil's Oven, and remnants of it can still be seen today on modern Route 109 at Lakeshore Drive in Westwood. Legend once held that frightened settlers used the cave as a hiding place during Indian attacks. Another legend tells of gold secreted there by famed pirate Captain William Kidd. While no treasure has ever been found underneath this rock, the rock nearby proved a source of wealth for several industrious people beginning in the nineteenth century. Part of the large outcrop of granite that extends from Westwood through Medfield and into Dover can still be seen today as one drives off the Route 128 exit ramp onto Route 109 South. The stone is known as Dedham granite, and it was used in the construction of some of the area's most distinguished buildings. It is believed that Plymouth Rock is a chunk of Dedham granite deposited on the Atlantic shore by the glacier some twenty thousand years ago.

Dedham granite has a distinct warm, rosy hue to it and was a much desired building material for use in large-scale civic building projects. One of the first structures to be made from the granite was the stone mill on Mother Brook, built in 1835 and converted into condominiums in 1988. Other notable Dedham buildings made of the stone include St. Paul's Church (1858), Memorial Hall (1868), St. Mary's Church (1880) and rectory (1915), the Boston and Providence Railroad Station (1882) and the Dedham Public Library (1888). The station was taken down in 1951, and stone from the demolition was used to reposition the front entrance of the library from Norfolk Street to Church Street, as well as to build a new wing. The most famous building made of Dedham granite

Above: The Stone Mill on Mother Brook. *Photo by author.*

Below: Dedham Square scene with three buildings made of Dedham granite: St. Paul's Church (far left), Boston and Providence Railroad Station (center) and Memorial Hall (to the right of train station). *Author's collection.*

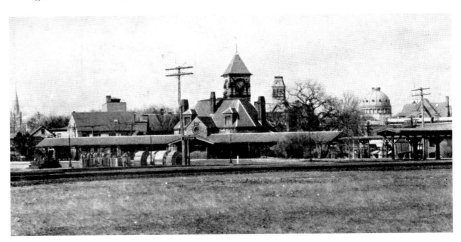

is the H.H. Richardson–designed Trinity Church (1872) in Boston. When reconstruction of the Route 1 overpass in 2008 necessitated the dismantling of the railroad bridge abutment at High Street, dozens of Dedham granite stones were artistically arranged between trees on a grassy strip alongside East Street.

Contentment

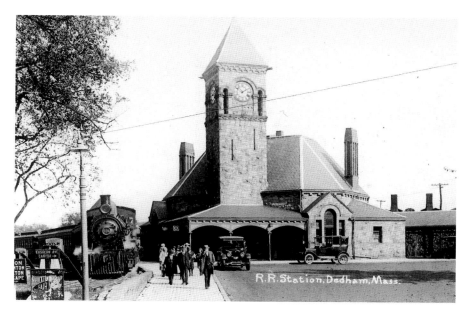

The Boston and Providence Railroad Station. *Author's collection.*

With the secession of Westwood from Dedham in 1897, the town's original land grant of some two hundred square miles was reduced to just over ten square miles. The vast wilderness that had so intimidated the early settlers was gone as well, with the only large tracts of undeveloped land remaining in the woodlands of the town forest and along the Needham border, and in the Greenlodge section of town. Homes began replacing the forests and farms of Greenlodge beginning in the late 1940s, and by 1955 the area was mostly developed, with its own neighborhood school. Residents from other parts of town derisively called Greenlodge "Peanut Butter Valley," suggesting that families could only afford to eat peanut butter after making the payments on their expensive new homes. Most of the town forest was taken by the state when Route 128 was built in the mid-1950s. In 1972, the state returned part of the land back to the town and plans were made to make the wooded hills available to hikers and picnickers. The seventy-one-acre parcel was situated between the northbound and southbound lanes of Route 128, making it the first town recreational facility located on a median strip.

Sometimes efforts to tame wilderness areas can have disastrous consequences, as was the case in 1923. The Charles River meadows as well as the Fowl Meadows to the southeast had long been a source of fuel in the

form of peat taken from the acres of bogs in the meadows. About 1908, the bogs were deemed a "pest hole" and drained. During a long period of drought in the summer of 1923, an environmental headache was created when the dry meadows caught fire and burned for weeks. Fires began that August in multiple locations, including Rodman's Woods off Westfield Street, Purgatory Swamp in Canton, Broad Meadow in Needham and Job's Island in the Charles. Smoke from the smoldering fires drifted over the center of town, causing many auto crashes. A driving ban through Dedham Square was put into effect, and streetcars had to be led by men holding ropes and carrying lanterns. On some days, the smoke cloud would drift as far north as Reading. Public works employees and citizen volunteers joined Dedham's eight-man firefighting force to battle the fires throughout September and October.

Despite the hazards, hundreds of spectators were drawn to the edges of the meadows to witness the odd occurrences that resulted from the fires, such as scores of frogs and chipmunks racing out of the burning areas seeking safety. The skies over the meadows were frequently filled with screeching birds fleeing the smoke. Fire officials agreed that only a sustained rainfall would end the fires, and when it finally began raining on October 15, two months after the fires began, the resulting steam cloud was as intense as the smoke from the original fire.

The Fairbanks House

In 1641, several men ventured into the woods and felled a large oak tree (with considerably more success than the Kingsberry brothers). The tree was stripped of its limbs, squared off and placed into position as a support beam inside a newly constructed home sitting on twelve acres to the northeast of Wigwam Pond. When the home was complete, it was occupied by Jonathan and Grace Fairbanks and their six children. The beam remained in place over the centuries as the world outside changed dramatically and the world inside the home changed very little. In 2001, a small section of the beam was removed and sent to Oxford University in England, where scientists, using dendrochronology (the study of tree rings), confirmed the year the tree was cut down and affirmed the home's status as the oldest timber frame house in America. Today, the Fairbanks House at the corner of East Street and Eastern Avenue is a National Historic Landmark and an ongoing subject of historical research.

Contentment

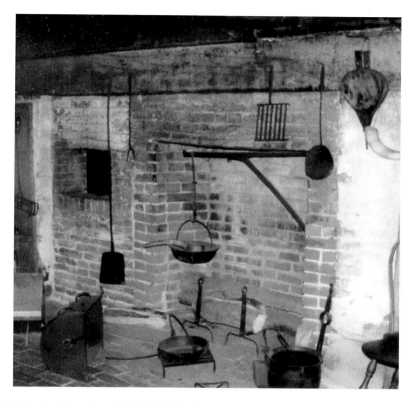

The Fairbanks House hearth. *Author's collection.*

Family tradition always held that the house dated to 1636, and this date has been painted on the outside of the chimney for years. This construction date was based on the year when Jonathan Fairbanks received his land grant. The original portion of the house was built using post and beam construction: squared off vertical posts joined together with horizontal beams. The openings between the posts were filled with a clay mixture spread over saplings (wattle and daub). In America, where woodland was abundant, the wattle and daub was then covered with clapboards of cedar or oak. The skill with which the frame of the Fairbanks House was constructed shows that it was built by professional carpenters, or joiners. Over the years, the appearance of the house changed as additions were made, but with each renovation and expansion, tell-tale clues to the original construction were left behind.

At the close of the nineteenth century, the house had become an archaic relic of Dedham's beginnings, as almost all of the other early homes had disappeared. The last family member to live in the house was Rebecca Fairbanks,

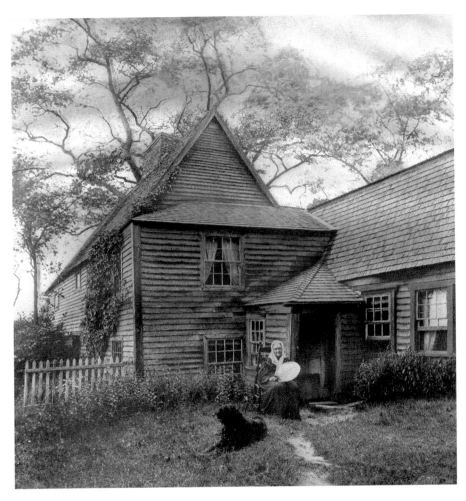

Rebecca Fairbanks and her dog. *Fairbanks Family in America, Inc.*

who inherited the property from her father's unmarried sister Nancy in 1879. Rebecca was the great-great-great-great-granddaughter of Jonathan and Grace and represented the eighth generation of Fairbanks family members to occupy the home. She moved out for a brief time in 1892 after lightning struck and killed her pet dog while it was sleeping in the house. When her financial situation worsened, Rebecca sold the property to Dedham realtor John Crowley in 1895, but was allowed to continue living there. Rebecca was still unable to make ends meet after the sale of the home, and she began selling off family heirlooms to get by. One item sold was a chest built by John Houghton in Dedham about 1658. When the chest came up for auction in 2003, Fairbanks family members

purchased the precious antique and returned it to its home in Dedham. It is kept in the Fairbanks House during the months the museum is open and is displayed at the Dedham Historical Society the rest of the year.

In 1897, John Crowley was prepared to tear down the home and develop the two-acre property. An appeal for a buyer in the *Boston Transcript* resulted in the purchase of the home and property by Mrs. J. Amory Codman and her daughter, Martha. The Codmans agreed to allow Rebecca to stay in the house, which she did until 1904, when the newly formed Fairbanks Family Association took possession of the property. Rebecca died in 1909. The house was opened to the public in 1905, with curators camping alongside the house in a tent. In 1912, a curator's house was built adjacent to the old homestead. This building is interesting in its own right, having been purchased from a Sears Catalogue. Each year, the association holds a family reunion at the home, welcoming descendants of Jonathan and Grace from all across the country. In 1907, Charles W. Fairbanks, the sitting vice-president and a Fairbanks descendant, attended the reunion at the old homestead.

Although the house did not officially become a museum until 1905, it had been host to curious sightseers from the time it came into Rebecca's

Scenes from the Fairbanks House drawn by a member of the Boston Bicycle Club in 1880. *Author's collection.*

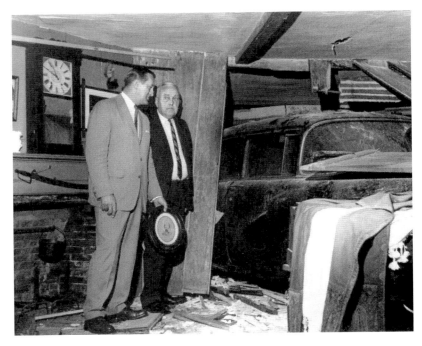

The destruction caused by the 1964 car crash. *Fairbanks Family in America, Inc.*

possession. One regular group of visitors was the Boston Bicycle Club, founded in 1876. For many years, the club's two-day "Wheel around the Hub" bicycle excursion through Boston's picturesque suburbs included a stop at the Fairbanks House, where riders of the high-wheelers would rest on the spacious and shady lawn. The cyclists were so fond of the spot that they planted a tree there in 1916 to commemorate the club's fortieth anniversary. Ten years later, a small group of club members gathered at the tree for an unusual ceremony.

When club co-founder Frank W. Weston died at age sixty-seven in 1911, his last wish was to be cremated and to have his ashes intermingled with those of his wife, who had died several years earlier. In 1926, some fifteen years later, an old friend and fellow cyclist named Fred Stark visited the Dorchester undertaker who had made the final arrangements for Weston, seeking the location of his burial. Stark was astonished to learn that the bicycling pioneer's last wish had never been carried out. In fact, the urn containing Weston's ashes was still at the undertaker's in a back storage room!

Unable to locate the ashes of Weston's wife, Stark and other members of the club met to decide on a proper final resting place for "the father

Close-up of the hearth with hex mark. *Author's collection.*

of American bicycling." On a Friday afternoon in September, friends gathered on the lawn of the Fairbanks House, where they consecrated the remains of their old friend to the ground under the tree that had been planted ten years earlier.

The Fairbanks House has survived a variety of near disasters in its long history. In 1916, renowned American furniture and print maker Wallace Nutting offered to restore the house in return for free rent. This "restoration" would have destroyed many of the home's important period details and, happily, was not undertaken. In 1964, a seventeen-year-old Dedham teen missed the turn on East Street and plowed his car into the east wing. Vandals tried to burn the house down on the Fourth of July 1967. In 1973, another car careening toward the house was stopped by the stone wall that had been built after the 1964 crash. Powder post beetles were eradicated from the home's posts and beams in the 1970s.

It may have been more than luck that kept the Fairbanks House safe from so many potential catastrophes. Its earliest residents took several precautionary measures in order to keep the home free from misfortune and evil. Deeply carved intersecting lines in the fireplace timbers are believed to be hex signs intended to keep witches and fire from harming the home and its occupants. Over the years, shoes have been found in the ceilings

The door latch of the Dedham Community House. *Photo by author.*

and behind the chimney, placed there to trap evil spirits as they attempted to enter the home. Other early Dedham residents took similar measures to keep their homes and families safe. When the seventeenth-century John Farrington House was renovated in the 1880s, a spoon was found under the foundation, placed there by the builders to give the house strength. A hex sign can also be found on the front door latch of the Dedham Community House, originally built for Judge Samuel Haven. A nearly identical mark found on the door latch of a house in West Brookfield, Massachusetts, inspired the name of the restaurant now operating there: the Salem Cross Inn. The Community House was built in 1795, long after the witch hysteria had faded from Massachusetts, so the hex mark may be nothing more than a superstitious touch added by the ironworker who crafted the latch.

While the hex marks may have kept the Fairbanks House and its contents protected over the centuries, it could do nothing to prevent the family's greatest tragedy from occurring in the spring of 1801, a tale that shall be related in another chapter.

Chapter Two

WASHINGTON SLEPT HERE
(JACKSON HAD A LIGHT LUNCH)

T he post roads and turnpikes that made their way through Dedham as early as 1679 brought many a traveler to town on foot, on horseback or by stagecoach. While most of these visitors were ordinary folks attending to business or visiting friends and relatives, occasionally a noteworthy citizen would arrive in Dedham with much fanfare and celebration. The taverns and inns in the busy center of town offered respite for all weary travelers, whether they be man or beast.

Two post roads intersected in Dedham on their way south from Boston. The Lower Road followed the path of modern High Street from Dedham Square, veering left on Court Street, right on Highland Street to Washington Street (Route 1A) and on to Providence and New York. The Middle Road followed High Street past the Dedham Common along modern Route 109 to Hartford Street in Westwood, and on to Connecticut. Later, these post roads would become toll roads, or turnpikes, so named for the wooden pole or pike that blocked the way until a fee was paid. The Lower Post Road was known as the Norfolk and Bristol Turnpike and the Middle Road became the Boston and Hartford Turnpike. Located ten miles out from Boston, Dedham became a convenient first stop on the journey southward as teams of horses were changed and dusty travelers got a chance to freshen up before continuing on their journeys. The taverns and inns in town were the centers of activity. Here, local political and social organizations met, parties and dances were held and, of course, thirsty patrons enjoyed a tankard or two of punch, flip, grog, silebub or toddy.

Ames's Tavern

One of the earliest taverns began operating on High Street in 1649 and was run first by Joshua Fisher and later his son. When the younger Fisher died in 1730, his widow Hannah took over operation of the tavern with the help of her four daughters. In 1735, one of these daughters, Mary, married a young man from Bridgewater, and the couple began running the tavern. This young man would become known in Dedham and throughout New England for accomplishments far greater than that of mere tavern keeper. Over the next thirty-six years, Nathaniel Ames II not only operated the tavern (at the sign of the sun), but also practiced as a doctor and produced a yearly almanac that preceded Benjamin Franklin's and in many ways surpassed it in creativity and wit.

Ames arrived in Dedham from Bridgewater in 1732 at the age of twenty-four. At the time, he had already been publishing the almanac for six years. The first issue came out in 1726, a full seven years before the better-known *Poor Richard's Almanack*, written by Benjamin Franklin. Many historians contend that Ames's almanac is a much better product than Franklin's and may have even been a model for the more well-known publication. It had a circulation of sixty thousand during its run and was a valued source of important information and entertainment during colonial times.

Each edition of the almanac contained a miscellany of astronomical information, humorous observations, inspirational quotations from the great thinkers, commentary on national and world events and quaint verses, such as these brief descriptions of seasonal changes in New England that twenty-first-century readers can easily relate to:

March
Just waked from sleep—
The minute frogs begin to peep. 1735

August
The Earth and Sky resound with thunder loud
And oblique streams flash from the dusky cloud. 1729

October
The SUN withdraws, and aged grows the year
No wing'd musicians charm the attentive ear:
Approaching Winter now begins his Threats
And Flora dies with morning's frosty Sweats. 1750

An *Aftronomical Diary*,

OR, AN

ALMANACK

For the Year of Our Lord CHRIST

1 7 2 6.

And from the Creation of the World,
according to the beft of Prophane Hiftory, 5675.
But by the Account of the Holy Scripture, 5688:
It being the Second after *Biffextile* or Leap-Year,
And the Twelfth Year of the Reign of Our Moft
Gracious Sovereign Lord KING GEORGE
Wherein is Contain'd the *Lunations*, *Eclipfes* of
the Luminaries, the *Planets* Motions & Mutual
Afpects, the Suns Rifing and Setting, Time of
High Water, *Courts*, *Spring Tides*, judgment of the
Weather. Together with many other Things
neceffary for fuch a Work.

Calculated for the Meridian of Bofton, N. England,
Whofe Latitude is 42 *deg.* 25 *min North.*

By NATHANIEL AMES, *Jun.*
Student in Phyfick and Aftronomy.

NOW *Seventeen hundred & Twenty Six the Sun,*
His annual courfe fince CHRIST *his Birth hath run.*
Strange Revolutions in this time have been,
In divers Lands, Kingdoms and Countries feen.
Some Years were happy, fome with Waes perplex,
And GOD *knows who fhall Live unto the next.*

BOSTON: Printed and Sold by *B. Green*, and
Sold alfo at the Bookfellars Shops. 1 7 2 6

Title page from the first edition of Nathaniel Ames's almanac. *Author's collection.*

Dr. Ames ran the tavern and published the almanac until his death in 1764. His widow Deborah (his first wife, Mary, died in 1737) took over the tavern, and when she married Richard Woodward the establishment became known as Woodward's Tavern (under the sign of the law book). It was here, on September 6, 1774, that a convention of citizens first met to draft the Suffolk Resolves, a precursor to the Declaration of Independence that outlined grievances with Britain over its many recent punitive legal actions against the Massachusetts colony.

Nathaniel II's eldest son, also named Nathaniel, continued producing the annual almanac until 1775. Like his father before him, Nathaniel III was a doctor, serving as the town physician for fifty years: administering smallpox inoculations, practicing bloodletting and delivering newborns. He began keeping a diary while a student at Harvard and continued to record his activities and observations until shortly before his death, a period of sixty-four years. The original diaries are in the archives of the Dedham Historical Society, and a two-volume edition edited by longtime town historian Robert Hanson was published in 1998.

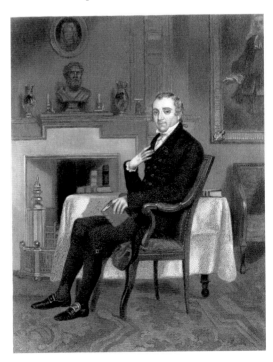

Fisher Ames. *Author's collection.*

Fisher Ames was the youngest of Nathaniel and Deborah's children, born in 1758 when oldest brother Nathaniel III was seventeen years old. An accomplished scholar, Ames entered Harvard at the age of twelve, graduating on the eve of the Revolution in 1774. Three years later, he had his master's degree and returned to Dedham to practice law at the tender age of nineteen. Ames was selected to represent Dedham in the Constitutional Convention of 1787, where his oratorical skills made him a leading figure among the delegates and a favorite of the Federalist Party. In 1789, Ames was elected to the First United States Congress. Ames

served three more terms in Congress, but chronic health problems, including mysterious maladies of the lungs, prevented him from seeking a fifth term, and he returned to Dedham to practice law once more. Ames finally succumbed on July 4, 1808, at the young age of fifty, and was honored with a lavish funeral in Boston before being buried in the family plot in the ancient burial ground on Village Avenue. For years afterward, politicians giving public speeches on the Fourth of July would be sure to include remarks honoring Ames, whose passing occurred, appropriately enough, on this hallowed anniversary day, and the celebration of our nation's independence would forever be entwined with remembrances of this great American statesman. That is, until July 4, 1826, when two other American statesmen, John Adams and Thomas Jefferson, died within hours of each other on the fiftieth anniversary of the signing of the Declaration of Independence.

The Norfolk Hotel

Martin Marsh opened up a tavern on the busy Norfolk and Bristol turnpike in a house he built in 1801. The inn was soon hosting political meetings, speeches, dances and social gatherings. Marsh ran the inn until 1818, when he sold it to Moses Gragg and Francis Alden, who renamed it the Norfolk Hotel. Alden left in 1821 to run Timothy Gay's Tavern on High Street in the center of town.

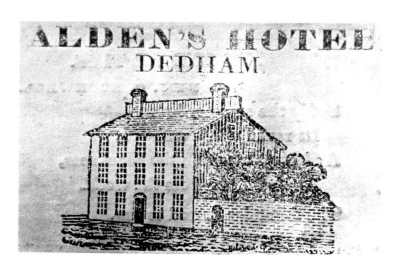

Early newspaper ad for Alden's tavern. *Dedham Public Library.*

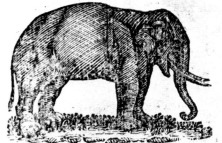

Newspaper ad for learned elephant. *Dedham Public Library.*

In May 1822, a "learned elephant" was exhibited on the grounds of the hotel, with customers paying twelve and a half cents to view the nearly eight-foot-tall creature. No ordinary elephant, the twelve-year-old female could balance on one pair of legs; drink from a bottle after removing the cork; and bow, whistle and deliver coins to her keeper after picking them up off the ground. After entertaining audiences in Dedham, the elephant and her keepers toured the rest of New England throughout the summer.

Francis Alden came back to the Norfolk Hotel in 1828 when Gragg left to open the Blue Hill Hotel in Milton. Under Alden, the Norfolk became the place to be in Dedham for many years. Alden built an addition that included a large third-floor ballroom sixty-eight feet long and twenty-eight feet wide, which became famous throughout New England for its spring-loaded dance floor.

One of the most memorable events at the Norfolk was the visit by President Andrew Jackson and Vice President Martin Van Buren in 1833. The men had been elected the previous fall and were making a tour of New England when they stopped in Dedham on their way to Boston. The president's carriage, pulled by four white steeds, entered Dedham around noon on June 22, where it was met with a twenty-four-gun salute. The Honorable James Richardson, president of the Norfolk Mutual Fire Insurance Company and chairman of the welcoming committee, gave an address. Jackson and his traveling companions then made their way to the Norfolk Hotel, where they were served lunch. After staying about an hour, the president and his entourage continued on their way to Boston.

Washington Slept Here (Jackson Had a Light Lunch)

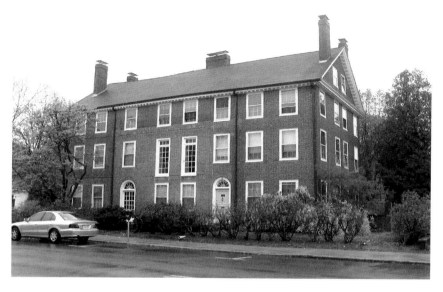

The Norfolk Hotel as it looks today. *Photo by author.*

In 1840, Martin Bates took over the hotel. Bates was a cantankerous old man who would "cabbage" (keep) any stray ball that rolled onto his property when accidentally tossed or kicked there by local youths. Bates became part owner of a moose that was kept in the yard of the hotel by him and the co-owner, a Mr. Crossman. Crossman had offered to buy out Bates, but Bates asked too large a sum. Crossman then changed the moose's diet so that it lost weight and began to look sickly. Bates could clearly see that the moose was wasting away and sold his interest to Crossman, who in turn fattened it up and sold it to a circus.

While Bates remained owner for many years, he employed a succession of landlords who ran the hotel at varying times as either a "dry" establishment or a "wet" one, with little regard for the liquor law in effect at the time.

One of the last significant events in the hotel before it ended its sixty-year run as a tavern was a grand ball given for the soldiers of the famous Fifty-fourth Massachusetts Regiment in May 1863. Shortly after the Civil War, the hotel fell into disrepute, and its last landlord was arrested for operating a public nuisance.

Bates offered to sell the building to the Town of Dedham, but was so insulted by the paltry sum they offered that instead he turned around and sold it for one dollar to the Sisters of Charity. The sisters opened the St. Mary's School and Asylum in the old tavern in 1866 and operated the school until its closing in 1879. In 1905, the building was converted into a private home.

Honest Abe Comes to Town

Down the road from the Norfolk Hotel is the mansion built in 1795 by Judge Samuel Haven, which has been known as the Dedham Community House since 1922. In 1848, the house was the venue for a luncheon attended by a little-known congressman from Illinois named Abraham Lincoln. The young congressman was making a tour of New England, stumping for fellow Whig Zachary Taylor in his bid for the presidency. Lincoln arrived from Boston on September 20 on a late afternoon train and was met at the Dedham station by a brass band. The band accompanied him to the Judge Haven House for an afternoon lunch. Lincoln then walked down Court Street to Temperance Hall, where he spoke for an hour. The reviews of his speech naturally fell along party lines, with the Boston-based Whig papers *Atlas* and *Courier* hailing the speech as a success, while the Democrat *Roxbury Gazette* called the appearance "a melancholy display."

Lincoln certainly impressed the young reporter who had accompanied him from Boston. George Moore at first found the future president aloof and quiet, but noted a remarkable transformation when Lincoln began to address the crowd, "all the time gaining on his audience. He soon had

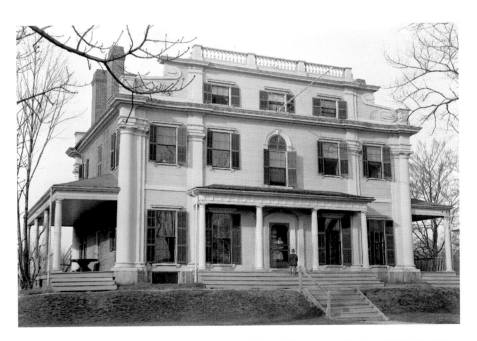

Judge Samuel Haven House. *Library of Congress, Prints & Photographs Division, HABS (HABS MASS,11-DED,5).*

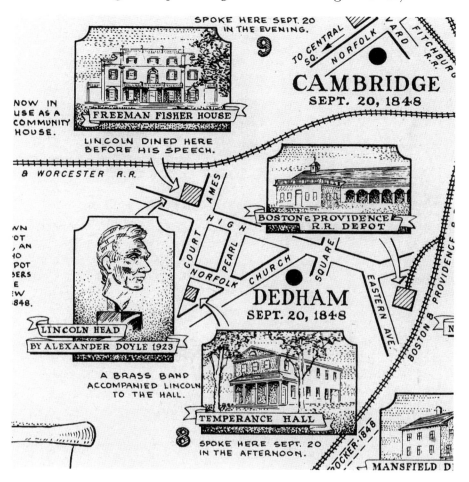

Portion of a commemorative map published on the 100th anniversary of Lincoln's New England visit. *Library of Congress, Rare Book and Special Collections Division, Alfred Whital Stern Collection of Lincolniana.*

us under his spell." After Lincoln concluded his remarks, the small crowd begged him to stay longer, but he was out the door as soon as he heard the locomotive pulling into the station.

A bronze bust of Lincoln sculpted by Dedham artist Alexander Doyle is on display in the dining room of the house on High Street where the sixteenth president once visited.

Phoenix House

Timothy Gay built a tavern on the corner of Washington and High Streets in 1792. President James Monroe stopped by in 1817 when the establishment was known as Polley's Tavern. The Citizen's Stagecoach Line, of which Gay was president, stabled its horses at the tavern and it was here, ten miles out from Boston, that the teams were switched after the first leg of the trip to Providence. In 1832, the entire structure, now known as Bride's Tavern, burned to the ground, destroying the attached stable and most of the horses. The inn was rebuilt and renamed the Phoenix House and was barely reopened in January 1834 when another fire broke out in the stables, again destroying the horses, but sparing the hotel. A man named John Wade was arrested for setting the fire. He was eventually found guilty of the crime and sentenced to death, although that sentence was later commuted. Wade's suspected accomplice, George Walton, was indicted but never tried for the crime. He had his hands full with other legal troubles.

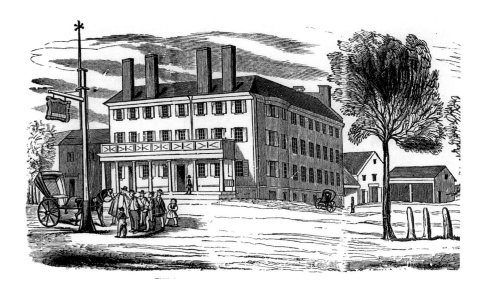

Phoenix House about 1835. *Author's collection.*

Tale of a Highwayman

Upon his release from the state prison in Charlestown in December 1833, George Walton (alias Jonas Pierce, alias James Pierce, alias James H. York, alias James Allen, alias Burley Grove) was advised by the warden to pursue "a living by honest industry." Walton had just finished serving two years for robbery, the only real profession he had ever practiced in his twenty-three years. After telling the warden that he wasn't quite sure which direction life would take him, Walton left the prison and immediately purchased two pistols, ending any uncertainty about his intended career path. Before the week was out, the highwayman was hiding in the woods along the Dedham Turnpike near Roxbury, waiting for potential victims. He soon found one in the person of Jabez Boyden, who was driving a wagon of goods toward Dedham. Walton robbed him at gunpoint and returned to his rooms in Boston. Over the next few days, he committed several more robberies before meeting up with John Wade, an old acquaintance from prison. Wade was planning to rob a bank in Rhode Island and convinced Walton to travel with him to look over the bank. The two met at the Norfolk Hotel, where Wade was residing, and then traveled on to Rhode Island. During the course of the journey, Wade hinted that he had been responsible for the fire that had destroyed Bride's Tavern a year earlier. He also let on that he knew it was Walton who had robbed Boyden on the Dedham Turnpike.

Finding the bank too heavily guarded to chance a robbery, the men returned to Dedham, and Walton took a room at the Norfolk. On the night of January 9, he awoke to the sound of bells ringing and saw the glow of fire through his window. The stables at the Phoenix were ablaze again, and Walton had a pretty good idea who was responsible. He quickly fled Dedham and concentrated his efforts north of Boston.

There he found a wagon driven by a Mr. Presser and Mr. John Fenno on the Salem Turnpike not far from the Chelsea Bridge. Pistols drawn, the mounted Walton gave the cry of "Your money or your life!" John Fenno decided that he would rather keep both and leaped off the wagon onto Walton. The stunned highwayman struggled with his would-be victim and fired a shot, which deflected off a buckle on Fenno's suspenders. Walton leapt on his horse and galloped away. He was arrested several days later on January 16. After a three-day trial, he was found guilty and sentenced to twenty years plus two years of hard labor at the state prison in Charlestown.

In May, Walton was indicted for the Boyden robbery. Before he could be brought to Dedham for trial, Walton escaped and headed to Canada. He remained at large from November 1834 until April 1835, when he was recaptured after returning to Boston.

Walton was finally brought to Dedham to stand trial for the Boyden robbery. His court-appointed attorney was Horace Mann, who practiced law in Dedham for several years before going on to become a noted education reformer. Mann managed to leave enough reasonable doubt in the minds of the jurors to cause a hung jury and force a second trial. While awaiting the second trial in the Dedham jail in November, the restless Walton made a daring escape attempt. After slipping from his shackles, he bolted from his cell when the door was opened at mealtime. The turnkey quickly jumped on the fleeing highwayman, and together they staggered through the hallway and down a flight of stairs. Only the intervention of a second jailer prevented Walton from making good his escape. The threat of being clubbed by this jailer forced Walton to give up, saying, "No harm done." Later, the jailers found seven small saws, two files, a chisel, a hammer and a knife, all hidden in a hollowed-out handle in Walton's cell.

Walton's second trial also ended in a hung jury, and he was returned to the Charlestown Prison. There, Walton befriended the warden and began dictating his life story, to be published later, as many first-person criminal narratives were at the time. But within a short time, Walton became gravely ill, and it was soon evident that he was dying.

During his final conversations with the warden, Walton spoke openly of his many crimes but adamantly denied any involvement in the burning of the Phoenix House stables at Dedham. He also related that John Fenno, who resisted the robbery attempt on the Salem Turnpike, was the only brave man he had ever met. Walton's dying wish was that his life story be printed and presented to Fenno as a testament to his bravery—a reasonable request. Then Walton took his request one step further, into the realm of the macabre—he asked that the book be bound in his own skin! Upon

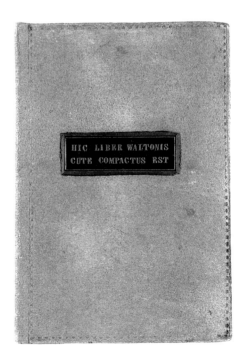

The gruesome cover of George Walton's narrative. *Boston Athenaeum.*

Walton's death from consumption in July 1837, his last wish was granted and the book was produced. A large portion of Walton's skin was removed from his back on the day he died and sent to a Boston bookbinder. The skin was tanned and fashioned into a deerskin-like cover and embossed with the Latin phrase *Hic Liber Waltonis Cute Compactus Est*, which loosely translates into "Here is the book of Walton made from his own skin." For many years, the book was used to paddle the behinds of miscreant Fenno children and grandchildren. The ghastly book was later used by those same children to frighten their neighborhood friends. Today, the book is owned by the Boston Athenaeum, a private library on Beacon Hill.

Dedham or Cooperstown?

Imagine you are in the bleachers at Fenway Park watching a playoff game between the Red Sox and their longtime rivals, the New York Yankees. It's a close game, with Boston leading 59–55 and nobody out. The Sox have a man on second base. The New York twelve are spread out on the rectangle, waiting for the home team striker to take his knocks. Here's the pitch—it's a long fly ball, caught by the Yankee outfielder; he catches it and hurls it toward home, plugging the Sox runner square in the back. "You're out!" hollers the referee, and the Yankees run off the field to take their knocks.

Had a group of local baseball club presidents meeting in Dedham in 1858 gotten their way, scenes such as this one would be played out on ball fields around the country each summer, and Dedham would be known today as the birthplace of modern baseball. On May 13, 1858, the Phoenix House hosted a convention of the Massachusetts Association of Base Ball Players, which came to the High Street hotel to draft a set of rules and regulations for the "Massachusetts" version of the popular sport.

Representatives from ten local ball clubs, including three from Boston and one from Dedham, worked all morning on drafting a constitution before breaking for a bountiful lunch supplied by Phoenix landlord J.D. Howe. According to Article I of the constitution adopted that day, the purpose of the association was to "improve and foster the Massachusetts game of baseball and the cultivation of kindly feelings among the different members of Base Ball Clubs in this state." While B.F. Gould of Boston's Tri-Mountain Club demonstrated "kindly feelings" as he addressed his fellow presidents that day,

he made it clear that his club would be withdrawing from the association in order to play the game under the rival "New York" rules.

The seventeen rules adopted by the association that day describe a game more like English rounders. The field of play was rectangular, unlike the diamond shape of modern baseball. Each team was allowed only one out per inning. Runners did not have to be tagged in order to be called out—a fielder could strike or "plug" the runner with the ball in order to make an out. The game ended when one team scored one hundred runs.

The New York game, introduced by the Knickerbocker club in the 1840s, was much closer to modern baseball. There was a great rivalry between proponents of the two versions of the game, and for a while after the convention the Massachusetts game proved more popular than the New York game. But the New York rules were easier to follow and made for a more exciting game, and as the city itself emerged as the center of trade and industry in America, the New York game became the standard. The Civil War helped to spread the popularity of the New York game, and in 1871, the establishment of the first professional league, operating under New York rules, signaled the end of the Massachusetts game. The only rules from the Dedham Convention that exist in modern baseball are the overhand pitch and the called strike.

After their long day's schedule of meetings, the gentlemen who had gathered at the Phoenix naturally celebrated their hard work with a ballgame, which was well attended by townspeople.

The Phoenix House was destroyed by fire in the early hours of Christmas morning 1880. The fire quickly tore through the large wooden structure, and adjacent buildings were spared in part due to the snow that had collected on their roofs. The hotel's owner, Henry White, who was also the turnkey at the county jail, had owned the forty-room hotel for about a year. At the time, the Phoenix was the only remaining inn in town, and Dedham's long tradition of hosting tired and dusty travelers had come to an end.

Washington Slept Here

In the course of his long military and political career, George Washington spent many a night away from home, giving rise to the claim by many New England inns and taverns that "Washington slept here." The 1762 Samuel Dexter House on High Street can legitimately make that claim, having sheltered General Washington on the night of April 4, 1776, as he made

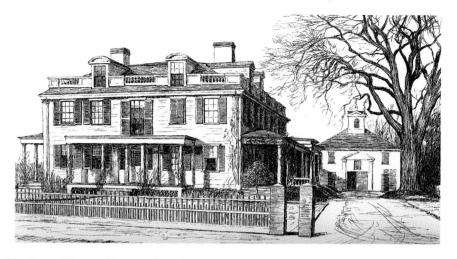

The Samuel Dexter House on High Street. *Collection of James V. Horrigan.*

his way to New York a few weeks after the British had evacuated Boston. At the time, a prominent Patriot from Boston named Joshua Henshaw was residing in the home. The owner of the home, Samuel Dexter, had removed to Woodstock, Connecticut, the previous year. Dexter was an eminent American statesman who in 1771 entertained the last royal governor of Massachusetts, Thomas Hutchinson, in the house on High Street before events in Boston made such meetings impossible.

It is possible that during General Washington's brief stay in Dedham, his host related to him the sad events that had transpired in the Dexter house just five months previously.

Graveyard Visitors

In the old graveyard on Village Avenue, there stands a large, ornately carved monument on which is inscribed the word "Bonnemort." While the stone is intended to mark the final resting place of the Bonnemort family, its location just inside the entrance gate makes the inscription a final send-off to the souls buried within the graveyard's walls. Just as one wishes a diner an enjoyable meal with the salutation *bon appétit*, the Bonnemort stone invites the dead to enjoy a peaceful eternal rest. As we shall see in these next few tales, some of those souls have had their rest disturbed by the curious, the well-intentioned and the mischievous.

The Odd Pursuits of Jabez Fitch

Upon the death of Nathaniel Ames II in 1764, poetic tributes appeared in publications across New England, including this verse by Samuel Ellsworth, a Connecticut almanac maker:

My muse with sable colours spread,
To hear that Doctor Ames is dead.
His great Seraphic genius fled.
Mourn, mourn, sons of Urania *Mourn,*
For he will never more return:
To hover 'round the starry brood,
For he's passed through the ecliptic road.
To worlds unknown he's took his flight,
The Grave's receiv'd him from our sight
Fame sits aloft and spreads her wing,
While we in mournful strains may sing.

While Ellsworth laments that "the Grave's receiv'd him from our sight," thanks to the macabre pastime of a Revolutionary soldier, readers today can enjoy a lurid description of the good doctor several years after commencing his flight to worlds unknown.

Lieutenant Jabez Fitch was a Connecticut soldier stationed at Roxbury during the siege of Boston following the Battle of Bunker Hill. Fitch served under the command of Colonel Jedediah Huntington from August through December 1775. During the time of his service, Fitch kept a diary of his activities, which included traveling, eating, drinking flip, taking care of his ten-year-old son Cordilla, who for reasons unclear was encamped with him, and visiting graveyards, a pursuit he admitted was "agreeable to my wonted practice of viewing curiosities."

Fitch's first recorded graveyard visit was in Dedham, where he made a brief stop in August while making his way from Connecticut to Roxbury. Upon reaching Dedham, he and his son stayed at Woodward's Tavern (formerly Ames's Tavern) and managed to fit in a trip to the ancient burial ground just a short distance away. Later, he wrote of three more tours of the Roxbury graveyards, including this gruesome account from October:

After dinner Cordilla and I returned to the camp by way of the burying
ground that I was at last Saturday. We there see another tomb open just
by and much like the other that I see last Saturday. We looked into it and

observ'd twelve coffins, small and great; among them was one some broken, the lid of which I rais'd up with my staff and see the head of a corpse which was reduced to nothing but only the bones, the skin and flesh together with the burying clothes being entirely consumed.

In November, the Connecticut regiment at Roxbury received sad news concerning the wife of their commander, Colonel Huntington. Faith Trumbull Huntington, daughter of the Connecticut governor and sister of the famed painter John Trumbull, had been staying at the home of Samuel Dexter in Dedham since the Battle of Bunker Hill. After witnessing that battle from a safe distance away, Mrs. Huntington became delusional and despondent. While friends tried to help the ailing woman in her emotional struggles, she fell deeper and deeper into despair, and ended her life with "a small cord" on November 27.

A contingent of Colonel Huntington's soldiers, including Fitch, traveled to Dedham for the funeral, where, according to her obituary, "Her precious Dust was, on the 28th, deposited in a friendly Tomb, after a very pious and excellent Prayer by the reverend and worthy Mr. Haven, attended by a numerous and respectable Assembly of kind and sympathising Strangers, of that Town and the Army adjacent."

The friendly tomb was that of the Ames family, and it held the body of the esteemed physician and almanac maker Dr. Nathaniel Ames II, who had died some eleven years earlier. Imagine the excitement of the tomb tourist upon arriving in Dedham to find the doctor's tomb standing open awaiting the body of Mrs. Huntington! Prior to the services, Fitch and some companions made their way to the graveyard. He later recorded these observations in his diary:

About 12 O'clock…went into the burying yard, where we found Doctor Ames' tomb open…We several of us went down into the tomb, opened the old doctor's coffin and see his corpse.

The under jaw was all fallen in, the other part of the bones of the head retained their proper shape, the teeth were whole in the upper jaw, but the whole back and rest of the body, as far as we could see, was covered with a black film or skin, which I suppose to be the winding sheet in which the corpse was buried, being blended with the moisture of the body.

I also observed one of the arms to have fallen off from the body and the bones laying by the side of the coffin. While I was thus in a sort conversing with the dead and viewing those melancholy curiosities, I could

not help reflecting that nothing of the philosophy and astronomy which once adorned the mind of that person and made him appear great among his contemporaries, was now to be seen in this state of humiliation and contempt…

After sufficiently gratifying our curiosity, we moved on.

Over one hundred years later, another prominent Dedham citizen was visited in the tomb while awaiting burial. Hannah Shuttleworth was a respected citizen in town who became the niece of Nathaniel Ames III when he married her father's sister, Meletiah. Upon the doctor's death in 1822, Hannah inherited his substantial estate at the age of twenty-two. Hannah died in 1886, leaving generous bequests to several civic institutions in town, including the historical society. In addition to the sum of $10,000, the society received the plot of land on which the Shuttleworth home had stood for almost one hundred years, allowing a new headquarters and museum building to be erected there. President Don Gleason Hill wanted to honor his friend and the society's benefactor with a portrait to be displayed in a place of honor in the new building. Unfortunately, no portrait had ever been made of Miss Shuttleworth. So Hill contracted a Boston statuary maker to travel with him

The Ames tomb in the Village Avenue Graveyard. *Photo by author.*

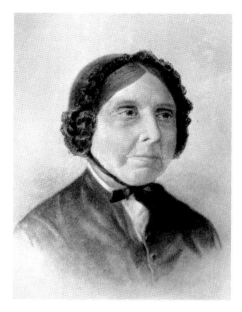

to the cemetery on Village Avenue, where Miss Shuttleworth's body lay in the receiving tomb awaiting burial. There they entered the tomb, and the sculptor, Giribaldi, made a plaster cast of the deceased's face. From that cast, a portrait was made that, in Hill's words, was "literally snatched from the tomb." Both the plaster cast and the portrait are on display in the historical society museum.

Portrait of Hannah Shuttleworth made from her death mask. *Author's collection.*

Dedham Spooks

There is no better setting for a haunting than an old cemetery, and for a few weeks in 1887, the old graveyard was the scene of bizarre and ghastly apparitions and disturbances. Ghosts, bloody gravestones, strange noises and spectral visions were reported to police on a regular basis beginning, appropriately enough, the week before Halloween.

The first reports were of a man described by many as a "spook" lurking near the Village Avenue graveyard. P.H. Hurley was accosted by the spook as he was walking by the graveyard. After a brief struggle, the specter fled, leaping over a tall fence, and Mr. Hurley continued on his way. He reported the incident to police, describing the man as being at least seven feet tall and dressed in a long blue coat. Later that night, John Ward encountered the spook in the Brookdale Cemetery as he made his way home from work. Many citizens took the threat seriously, including one woman from Oakdale who fired her shotgun at the spook.

Other witnesses claimed to have seen a spectral woman roaming the graveyard, pointing at various grave markers and remaining still and quiet when questioned. The details given to police and newsmen got stranger and

stranger. One report claimed that the spook was fond of eggs, so a local grocery was investigated. Doors that were usually left unlocked were double barred, and nervous housewives were reluctant to let their husbands enter until they had proof positive of their identities.

On the night of November 8, the spook sensation took a new twist when Henry Humphrey heard shots at about midnight while trying to get to sleep in his home bordering the old graveyard. The next morning, cemetery caretaker John Carey made a frightening discovery at the grave of Lavinia Turner. The white marble gravestone was spattered with large amounts of what appeared to be blood. The ground surrounding the gravestone was torn up as if a struggle had taken place there. A bloody handprint was found on the iron rail surrounding the Turner plot. Along the path leading away from the plot was a trail of trampled grass, showing evidence of a large object being dragged. Constable de Morse confirmed that it was indeed blood discovered in the graveyard, while Chief of Police Drugan was convinced that it was simply red ink. Despite assurances from the chief that the entire "spook sensation" was the work of pranksters, the town remained on edge for some time afterward, until the sightings and incidents faded away. While the Boston and New York papers reported every detail of the "sensation," even sending a reporter out to spend the night in the graveyard, the *Dedham Transcript* labeled the sensation a series of pranks that "could only have originated in the mind of a dime novel reader of youthful years." They opined that the stories were nothing more than food for reporters and would die down with the first rainstorm. The "spook sensation" faded as quickly as it had begun when headlines were stolen by a black-shrouded figure haunting a Palmer, Massachusetts cemetery in mid-November.

Chapter Three

SHIRETOWN CRIME AND PUNISHMENT

In 1793, a new county named Norfolk was formed from parts of Suffolk County, and Dedham was chosen to be the county seat, or shire town. Two immediate needs of the new county were a courthouse and a jail. A wooden courthouse was built on High Street in 1795. This building was subsequently moved to Court Street, where it was later known as Temperance Hall. It burned down in 1891.

The cornerstone for the second courthouse was laid with great ceremony on July 4, 1825. This structure was made of Dover granite quarried in Medfield and was completed in 1827. Additions and improvements were undertaken in 1862 and 1895.

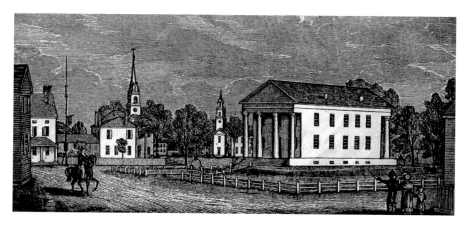

The courthouse in the 1830s. *Author's collection.*

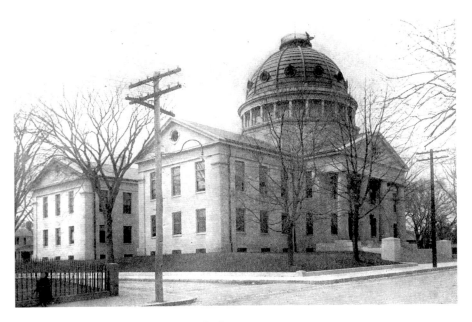

Norfolk County Courthouse. *Author's collection.*

The original jail for the county was on Highland Street, behind Gay's Tavern. The first prisoner took up residence in February 1795. A second, stone jail was built in 1817 and enlarged in 1851. After an escape by thirteen prisoners in 1989, a court order closed the jail, and a new facility was built on the median strip between Route 128 North and South.

Many of the first inmates to occupy the original jail were petty criminals and debtors, but in May 1801 a young man from a prominent Dedham family was arrested and jailed for committing a "deed of horror."

Jason Fairbanks and Elizabeth Fales

The remaining landmarks of Dedham's greatest tragedy are fittingly gothic in their appearance: the rambling, almost medieval Fairbanks home on East Street; the slate gravestones in the ancient graveyard, one with a weeping willow carved above the shocking inscription that only hints at the terrible details of the tragedy: "Sacred to the memory of Miss Elizabeth Fales, daughter of Mr. Nehemiah and Mrs. Sarah Fales who was found murdered

May 18, 1801, in the 19th year of her age." Below that a hopeful verse attempts to give some comfort to the murdered girl's grieving family:

Sainted shade of heavenly birth,
Of matchless innocence and worth,
Since God decreed you should be slain,
We'll cease to mourn nor dare complain.
Guardian angels watch thy swift career,
Thy soul in heaven will soon appear.

Just steps away is the marker for the young man who was tried, convicted and hanged for the crime. In contrast to the flowery inscription on the Fales monument, the small stone reads simply: "Sacred to the memory of Jason Fairbanks who departed this life September 10, 1801. Aged 21 years."

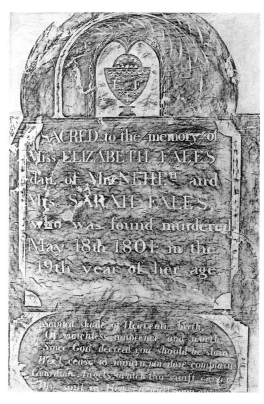

The gravestone of Elizabeth Fales. *Author's collection.*

Jason Fairbanks and Elizabeth "Betsey" Fales had known each other for most of their young lives, growing up in a small town and attending services together at the First Parish Church. Although at trial most of Elizabeth's family denied knowledge of any attachment the two had, the pair was frequently seen together in the months leading up to the tragedy. Despite their testimony to the contrary, Elizabeth's parents were certainly aware of the relationship, and did not approve. Jason had limited opportunities in life due to a withered arm and chronic health problems. This disapproval forced the young lovers to meet away from the watchful eyes of Elizabeth's parents. One favorite location

for their clandestine meetings was a grove of birch trees in a field known as Mason's Pasture, not far from Elizabeth's home near the intersection of present-day Cedar and Turner Streets. On the afternoon of May 18, 1801, the two had one last fateful meeting in the grove, where some act was done or particular words were spoken that provoked a horrific assault on the girl and sent the young man running to her family home covered in blood. Elizabeth's father and uncle rushed to the thicket to find the girl dying from eleven stab wounds to her arms, hands, side and throat. Jason also had several serious stab wounds, which he told the Fales family had been self-inflicted, as had Elizabeth's. The nature of Elizabeth's wounds indicated otherwise, and Jason was arrested for murder, his own wretched condition causing him to be carried on a litter across town to the jail the day after Elizabeth's funeral.

The trial began on August 6 in the same meetinghouse where Jason and Elizabeth had initially become acquainted, the courthouse proving too small for the enormous crowd that had arrived to witness the proceedings. A massive amount of testimony was heard in the two-day trial, most of it damning to Jason. Several witnesses recounted conversations in which he spoke of "settling the matter" with Betsey or "having satisfaction" with her. A young man who worked for the Fairbanks family testified that on the morning of the tragedy, he had lent Jason the knife that proved to be the murder weapon. Prosecutors portrayed Jason as a frustrated suitor who could never have satisfaction with Betsey due to either her own disinterest or her parents' interference. His defense team tried to convince jurors that Elizabeth and Jason had pledged mutual suicide and that only Elizabeth had succeeded in carrying out the deed. They also contended that Jason's weak physical condition made it impossible for him to have wielded the knife against Betsey so brutally and forcefully. But the physical evidence just could not support the defense team's position. No matter what the two lovers intended when they met in the birch grove on that spring afternoon, the fact remained that the location and severity of Betsey's wounds overwhelmingly indicated murder, and Jason was the only other person in Mason's Pasture at the time of her attack. Jurors deliberated for ten hours before returning with a verdict of guilty.

Despite the conviction and the overwhelming evidence that proved it to be a proper one, Jason had his supporters, and a small group of them was determined to rescue their friend from the hangman's noose. In the early morning hours of August 18, Jason was liberated from jail by a rescue party that included his older brother, two nephews and several friends.

Accompanied by a man named Henry Dukeman, the escaped felon made his way across the state to New York, where he hoped to cross Lake Champlain into Canada.

A party of three men—Captain Henry Tisdale, Seth Wheelock and Moses Holt—pursued Jason and Dukeman and caught up with them in Whitehall, New York. Jason was stunned that he had been so relentlessly hunted and was taken back to meet his fate. Not wanting to risk another escape, authorities held him in Boston until his execution date.

On September 10, Jason was remanded to the custody of Norfolk County sheriff Benjamin Cutler. Several cavalry companies and a volunteer guard of Dedham citizens were on hand to ensure peace in town throughout the day. Shortly before three o'clock, Jason was taken from the Dedham jail to the common, where a crowd of some ten thousand spectators had turned out to witness the county's first public execution. Jason had no final words as he was led to the gallows; he quickly indicated that he was ready to meet his fate by dropping a white handkerchief, the customary signal given by condemned prisoners.

Another custom of the time was the printing of poems, biographies, commentaries, eyewitness accounts and confessions on single- or double-sided sheets called broadsides, which were sold to the eager public for a penny or two. The only image of the hanging on the Dedham Common that day is a woodcut appearing at the top of a broadside entitled *Biography of Mr. Jason Fairbanks and Miss Eliza Fales*. The woodcut pictures a detachment of soldiers standing at attention behind the hanging body of Jason, wrapped in his winding sheet. Other publications quickly appeared in the days following the execution, including the *Report of the trial of Jason Fairbanks, on an indictment for the murder of Elizabeth Fales* and *A sermon preached in the first parish of Dedham, September 13, 1801, being the Lord's Day after the execution of Jason Fairbanks. By Thaddeus Mason Harris, A.M. Minister of the Congregational Society and Church in Dorchester*. In December, the curious public was treated to *The Solemn Declaration of the late Unfortunate Jason Fairbanks*, a fifty-page document containing a protestation of innocence dictated by Jason himself, followed by an account of his life and character written by his older brother Ebenezer. Enterprising showmen featured the tragedy in traveling waxworks museums, such as the one operated by Davenport and Bishop, which arrived at Mr. George Heike's tavern (at the sign of the bear) in Carlisle, Massachusetts, in May 1803. For a twenty-five-cent admission (half price for children), curious patrons could view wax likenesses of Napoleon, George Washington,

The Dedham Common at the end of the nineteenth century. *Dedham Public Library.*

Aaron Burr and Alexander Hamilton dueling, Shakespeare's Othello and Desdemona and a tableau entitled *The Road to Ruin or the Riotous Fellow Taken by the Watchman*, which featured "a striking likeness of Jason Fairbanks who was executed at Dedham, dressed in the same clothes that he wore at the time of his trial and the beautiful Eliza Fales."

Other Norfolk County Hangings

In a most extraordinary coincidence, on the first anniversary of the death of Elizabeth Fales, a murder took place at nearly the same hour in a different Mason's Pasture. The victim, William Allen, was beaten to death with a shovel by his brother-in-law, Ebenezer Mason, at Mason's farm in Medfield. Mason was hanged on the common on October 7, 1802, in front of yet another large gathering, including five-year-old twins Hepzibah and Sally Colburn, who had also been present at the execution of Jason Fairbanks. As the condemned man was being led to the gallows, he inquired of Hebzibah what she was doing there, to which the young girl replied, "To see you hanged!" Mason's body was stolen from his grave shortly after burial and was never found. In another bizarre coincidence, Mason's father died at his Medfield farm six months later—breaking his neck in a fall from a scaffold.

In 1804, spectators gathered on the common to witness the third hanging in just three years when eighteen-year-old John Battus of Canton was executed for the murder of a young girl. As with the two previous executions in Dedham, there was great public interest in the gruesome details of the murder, and within a few days of the execution the "confessions" of Battus were published and sold. By 1829, there was little indication that public taste for executions was waning. In July of that year, a spirited crowd took to the streets of town in a festive mood, eagerly awaiting the execution of John Bois, who had been convicted of murdering his wife earlier that summer. The county sheriff scheduled the execution for nine o'clock in the morning, hoping to limit the size and enthusiasm of the crowd, but the early hour had little effect. Hundreds of spectators drunkenly spilled out of public houses to watch the cart carrying the doomed prisoner to the gallows. The carnival-like atmosphere provoked strong criticism of the spectacle from many an outraged citizen, including a reporter for the *Boston Patriot* who wrote, "In those assembled there was no appearance of that solemn feeling which the public dismission of a fellow being to his long and last account ought to produce."

The event fueled the fires of the capital punishment debate, and it would be thirty years before another death sentence was handed down in Norfolk County. In that case, a compromise was reached with the execution of George Hersey of South Weymouth: while still open to the public, the hanging took place inside the Norfolk County Jail and attendance was by invitation only.

Hersey, a twenty-nine-year-old shoe company employee from South Weymouth, had been engaged to Mary Tirrell of the same town when she became ill with a mysterious illness in December 1859. Hersey moved into the home of Mary and her parents to minister to his ailing fiancée, who died in January 1860. Hersey stayed on with the family and in a short time became the constant companion of Mary's older sister, Betsy Frances, known simply as Frances. On the night of May 3, Frances woke up with sudden and violent spasms and died within minutes. An autopsy revealed that she had large amounts of strychnine in her system and that she was three to four months pregnant. Hersey had insisted on being present at the autopsy in the Hersey home, and his behavior and the questions he asked of the doctor quickly made him the chief suspect in the poisoning. He was soon arrested after investigators found a druggist in Boston who remembered selling strychnine to Hersey a few weeks prior to Frances's death. Wilson Tirrell, father of the deceased girls, then ordered the exhumation of his daughter Mary's body. Examination of her stomach contents also indicated strychnine poisoning, and as if that news wasn't shocking enough, people in Weymouth began

Admit _H.O. Hildreth_

TO THE JAIL, DEDHAM,

On Friday, Aug. 8, 1862.

Admit at 9 o'clock, A. M.

No Admittance after 9 1-2 o'clock.

John W. Thomas Sheriff.

An unused ticket to the George Hersey execution. *Dedham Historical Society.*

recalling the sudden death under similar circumstances of Hersey's wife Emeline several years previously.

George C. Hersey was found guilty after a four-day trial in May 1861. A gallows was constructed in the octagonal rotunda of the Dedham jail, and the execution took place on August 8, 1862. Over three hundred invited guests received tickets to the execution. When supporters continued to proclaim Hersey's innocence and protest his conviction and execution, Sheriff Thomas released Hersey's confession, written on the morning of his execution.

The second and last hanging in the jail took place on June 25, 1875, when James H. Costley of Hanover was executed for the murder of Julia Hawke, who was found shot in the head at Weymouth Landing on May 25, 1874. The *Boston Globe* reported on the clamor for tickets to the execution: "There has been a great demand for tickets of admission to the final ceremonies. One man, being desirous of taking his family as he would to a harbor excursion or picnic asks for five tickets. It is comforting to know that he will receive none. Many have asked for three each."

The Phoenix House was filled to capacity in the days prior to the execution with Boston policemen called in to keep the peace as well as curious citizens from across the region. Three hundred ticketed spectators filed into the Dedham jail on June 25, 1875, taking their seats in the same rotunda in which George Hersey had been dispatched thirteen years earlier. At 9:47 a.m. the hanging occurred, with Costley's body twitching and convulsing for close to

two minutes. The ghastly sights and sounds of the hanging were enough to cause one witness, a Mr. Ames of the Norfolk Fire Insurance Company, to fall headfirst onto the floor in a faint. After Costley's body was removed from the scene, the large crowd that had been lingering outside managed to get into the jail and retrieve pieces of the hangman's rope, morbid souvenirs of the last execution to take place in Norfolk County.

Sacco and Vanzetti

With the exception of Jason Fairbanks's brief journey to the shores of Lake Champlain after his escape attempt, the affair was strictly a local one: Jason's crime, trial, imprisonment, execution and burial all happened within a few miles of his birthplace. The county's most well-known trial and one of the most controversial criminal cases of the twentieth century, on the other hand, featured international players and a worldwide audience. The defendants, Nicola Sacco and Bartolomeo Vanzetti, were immigrants from Italy. The defense attorney was from California. The judge lived in Worcester. Supporters of the defendants ranged from poor immigrants in working-class cities across the globe to wealthy and prominent writers, poets and celebrities.

Sacco and Vanzetti were self-professed anarchists who were arrested in May 1920 for the murder of two South Braintree shoe company employees during the robbery of the company's payroll. After a six-week trial in the Norfolk Superior Court in the summer of 1921, the men were found guilty and sentenced to death. Those in agreement with the verdict cite ballistics evidence, eyewitness testimony, the behavior of the defendants at the time of their arrest (both men were carrying weapons and lied to police about their recent activities) and the lack of credibility of the alibi witnesses. Critics of the verdict contend that anti-immigrant bias led to a conviction based on the defendants' nationality and political views. The comments made by trial judge Webster Thayer outside the courtroom where seen as especially prejudiced. Worldwide demonstrations and protests supporting the men and decrying the legal process followed the convictions and intensified as their execution date approached. After an appeals process that lasted for five years, Sacco and Vanzetti went to the electric chair in the state prison at Charlestown on August 23, 1927. The case remains as controversial today as it was over eighty years ago, with historians and legal experts still debating the evidence, the behavior of the judge and jury and the verdict. Dozens

The main courtroom in the Norfolk County Courthouse. *Dedham Public Library.*

of books have been written on the topic, some concluding that the verdict was correct, others that neither of the men was guilty and still others that only one of the pair was guilty. While the protestors could not save the lives of Sacco and Vanzetti, their efforts did bring about important changes in Massachusetts legal procedure. Legislation was passed that gave the Supreme Judicial Court more power to review cases and reverse death sentences. Other procedural changes allowed judges a wider range of questions to use in determining the potential prejudices of a juror. Governor Michael Dukakis observed the fiftieth anniversary of the executions by issuing a proclamation declaring a Sacco and Vanzetti Memorial Day. While the governor's remarks acknowledged that prejudice during the trial had failed the men, he neither pardoned them nor declared their innocence.

While many people have a basic knowledge of the case, the facts that follow will shed more light on the episode and its connection to Dedham:

*Although the names Sacco and Vanzetti are forever linked in history, they spent much of the seven years following their arrests in separate jails. Vanzetti had been tried and convicted of attempted robbery in Bridgewater in 1920, and was sentenced to seven years in the state prison in Charlestown, where he was held until his 1927 execution, with the exception of his stay

at the Dedham jail during the trial, sentencing and appeals. Sacco spent the entirety of his time in Dedham, save for a short trip to Bridgewater for observation after a hunger strike and two weeks in the Death House in Charlestown prior to his execution.

*Residents living near the jail sometimes saw Sacco's seven-year-old son Dante standing on the sidewalk outside the jail grounds, playing a game of catch with his father, who was exercising in the prison yard behind the wall.

*The all-male jury (women were not allowed to serve on juries in Massachusetts until 1950) was sequestered for the six-week trial in the courthouse. They slept on cots in the grand jury room and bathed in the basement of the same jail where Sacco and Vanzetti were being held. On the Fourth of July 1921, the members of the jury were taken on an outing to the Scituate shore, where they enjoyed a lobster dinner.

*Part of the testimony in the trial was given outside, on Norfolk Street behind the courthouse. The alleged getaway car had been parked there, and jurors, attorneys and witnesses gathered on the street and sidewalk to view the auto and listen to testimony.

*Mrs. Sacco stayed at the home of Supreme Court justice Louis D. Brandeis on Village Avenue for a time during her husband's imprisonment, as a guest of Mrs. Brandeis.

*Over six hundred men were questioned as potential jurors before a full panel could be seated. The most common reason for being excused from the jury was opposition to the death penalty. One sugar dealer attempted to get out of duty by feigning deafness and was caught after he casually answered the judge's questions, sending Sacco and Vanzetti into fits of laughter. After five hundred interviews yielded only seven jurors, Norfolk County deputies scoured the area, finding potential jurors at club meetings, band concerts and on the job. One juror from Quincy was taken from his wedding dinner and forced to postpone his honeymoon until the trial was over.

*A cap found at the crime scene was claimed by the prosecution to be Sacco's. In a scene similar to that of the famous ill-fitting gloves in the 1995 trial of O.J. Simpson, defense lawyers had Sacco try to put the cap on, with comic results, as the ill-fitting cap rested on top of his head like a child's party hat.

*A convicted murderer jailed alongside Sacco in Dedham confessed to the murders in November 1925. While awaiting a retrial in a separate murder case, Celestino Medeiros slipped a note into Sacco's cell alleging his own involvement with a group of Italians in the South Braintree robbery and murder and declaring Sacco and Vanzetti innocent. Trial judge Webster Thayer dismissed the confession as a poorly crafted fabrication told by "a robber, a liar, a rum-runner," among other things. Medeiros was found guilty in his retrial and was executed at Charlestown just minutes before Sacco and Vanzetti.

*During the trial, Sacco and Vanzetti sat in a wrought-iron "cage" used for defendants in capital cases throughout the commonwealth. The structure was more like a fancy Ferris wheel car than an actual cage, with tall sides and an open top and front. The cages were removed from all Massachusetts courthouses in 1960 as part of a civil rights initiative by state attorney general Edward McCormack. The cage was also used in the 1934 trial of bank robbers Murton and Irving Millen and Abraham Faber.

The Millen Brothers

On April 14, 1934, the famed passenger train from New York to Boston, the Yankee Clipper, made its first ever stop at the Readville Station. A crowd of several thousand eagerly awaited the train's arrival that afternoon, hoping to get a glimpse of two of its passengers. These passengers were neither glamorous movie stars nor brave adventurers arriving to a hero's welcome. The train was carrying two young Roxbury brothers accused of robbing a Needham bank and shooting two policemen in cold blood in February of that year. They had been captured in New York and were on their way to the Norfolk County Jail to await their trial for robbery and murder.

After pulling into the station on time, Murton Millen, twenty-three, and Irving Millen, twenty-one, emerged from their railroad car under heavy guard, the mob greeting them with a chorus of boos and hisses. Soon a convoy of some forty cars was making its way across town, sirens wailing and horns blasting. The approaching noise of the caravan brought dozens of spectators outdoors as it made its way down High Street toward Dedham Square. There, the bystanders watched in amusement as the lead car stopped at the intersection of High and Washington Streets to inquire of

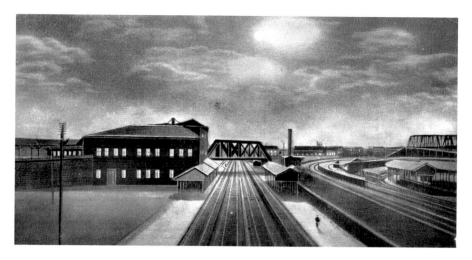

The train station at Readville where the Millen brothers were met by an angry mob. *Author's collection.*

the traffic officer John Keegan directions to the jail. Even more astonishing was when Keegan jumped on the running board of the lead car and led the caravan the few blocks to the jail. There, the brothers joined their accused accomplice, twenty-five-year-old MIT graduate Abraham Faber, who had been captured earlier.

It is not difficult to read the news accounts of the Millen brothers' exploits and think that you are reading the script from a 1930s gangster film. On February 3, 1934, the Needham Trust Company was held up in a hail of submachine gun fire, complete with the obligatory auto chase through town. The robbers were making their way out of the bank with $15,000 when a bank employee sounded the alarm. Needham police officer Forbes McLeod responded to the alarm and was gunned down almost immediately. The holdup men then fled the scene with two bank officials as human shields. The bank employees were forced to cling to the running boards of the getaway car as it sped through town. As they made their way through town, the bandits spotted a Needham firefighter and police officer chatting in front of the fire station, unaware of the robbery. Nonetheless, the bandits opened fire, killing Patrolman Frank Haddock and seriously wounding fireman Timothy Coughlin. After hanging on for dear life for several miles, the bank employees jumped to safety and the robbers sped away.

While local and state police worked on tracking down the killers, nervous authorities in Dedham discussed the incident at a special meeting, where one selectman recommended the purchase of a submachine gun for the police force.

Police got their first break in the case several days later, when the burned-out wreckage of the getaway car was found in a wooded area in Norwood. Examination of the debris by an auto expert revealed that the battery was not original to the car and had been rented from a repair shop. After canvassing auto repair shops in the area, policemen were able to obtain the names and Boston address of the brothers, where they found information identifying Abraham Faber as an accomplice. Letters found in the apartment revealed the brothers' hideout at a New York hotel. Faber was quickly arrested in Boston, and New York City police authorities were sent to the Hotel Lincoln to apprehend the Millen brothers.

Irving was picked up without incident, but Murton Millen engaged police in a gun battle in the hotel lobby, slightly wounding a detective before being whacked on the head and placed into custody by a quick-acting patrolman. Arrested with the brothers was the femme fatale in this gangster drama, Murton's beautiful nineteen-year-old wife Norma, the daughter of a Natick minister.

Before the brothers were sent back to Massachusetts, Abraham Faber had confessed his involvement in the Needham holdup as well as two other fatal robberies in Lynn and Fitchburg. The confession prompted the release of two Boston taxicab drivers who had been on trial in Salem Superior Court for the Lynn holdup and murder. Their trial was halted just as final arguments were to begin, and the defendants were released after the judge ordered a directed verdict of "not guilty" based on the new information. The ordeal of the innocent men was dramatized in a 1939 film entitled *Let Us Live* starring Henry Fonda and Maureen O'Sullivan.

On February 28, the Millen brothers and Abraham Faber were indicted for the murders of Officers McLeod and Haddock. All three defendants pleaded not guilty by reason of insanity, but the men apparently had no intention of ever stepping into the courtroom. On March 31, guards confiscated an escape plan from Faber that Murton had written on a magazine page with the burned end of a match. In May, after being permitted to exercise on the tier in front of his cell, Irving lunged for the pistol of a state trooper in an apparent attempt to shoot himself.

The trial began in April and attracted curious onlookers to Dedham from all over the country. More than once, out-of-towners entered the historical society building on High Street, believing it to be either the courthouse or jail. Hundreds of people, including schoolchildren, waited on the steps of the courthouse each morning hoping to catch a glimpse of the defendants or, better yet, get a seat in the courtroom. Some tried to push their way in while others took a more devious approach by dressing in suits and carrying

Above: A courtroom scene from the Faber/Millen trial. *Courtesy of Walter Timilty, Norfolk County clerk of courts.*

Below: The defendants in the cage, *from left:* Irving Millen, Murton Millen and Abraham Faber. *Courtesy of Walter Timilty, Norfolk County clerk of courts.*

briefcases in an attempt to pass themselves off as lawyers. One trial spectator was movie actor Roscoe Ates, known for his humorous stuttering act. When court attachés heard that the comedian was attending the trial, they had him served with a phony arrest warrant that ordered him to appear in district court.

After the joke was revealed, Ates showed that there were no hard feelings by treating the court workers to one of his comic stuttering routines.

Reporters from across the nation were as interested in the beautiful wife of Murton Millen as they were in the trial testimony. As Norma Millen awaited her separate trial for accessory after the fact, every available detail of the beauty's ordeal behind bars was reported. When it was heard that Norma didn't care for the jailhouse cuisine, local deli owner Isaac Moran gladly posed in full chef's attire for photographers, offering to personally prepare meals for Mrs. Millen. Photographers scaled the prison walls hoping to get a shot of her whenever she was allowed out into the jail yard for daily recreation. When local police put a stop to the wall climbing, the shutterbugs resorted to climbing up into trees or onto the roofs of nearby homes.

On June 8, the three men were found guilty and received the mandatory sentence of death in the electric chair at Charlestown State Prison. The following winter, while the condemned were awaiting transfer to the Death House at Charlestown, an old friend of the Millen brothers attempted to orchestrate their escape from the jailhouse in Dedham. In the early morning hours of January 4, ex-convict Edwin Frye managed to scale the prison wall with a homemade rope and make his way into the jail yard. From there, he climbed a fire escape and fired a shotgun through the window of Irving Millen's cellblock, blasting the lights out. At the same time, Irving Millen had gotten guard William Matta to open his cell door, whereupon he began pummeling him with a chamber pot after attempting to blind him with pepper he had saved up from mealtimes. Frye then tried to throw a revolver and ammunition through the broken cell window, but the prison turnkey arrived on the scene and the Millens' would-be liberator fled back over the wall. Frye was quickly apprehended by Dedham police after they received a call from an alert neighbor on Bullard Street who had witnessed him scaling the wall. Henry Millen and Mary Millen Cuthbridge, siblings of the condemned brothers, were later arrested for their part in the escape attempt.

In February, the three men received the official sentence of death. To the judge's pronouncement of the obligatory "May God have mercy on your soul," Murton Millen replied, "Don't worry, he will!"

After several unsuccessful appeals, the Millens and Faber were executed in the electric chair at the state prison in Charlestown on June 7, 1935. Irving Millen was the only one of the condemned men to offer any final words, a cry of "I salute my brother Murton!" as he was escorted to the death chamber.

At the graveside services for the brothers, a few of the twenty-five mourners got involved in a scuffle with some of the one thousand curious spectators

who came out in the rain to witness the burial. Two months later, Murton Millen's twenty-year-old widow Norma was released from the Dedham jail after serving eleven months of her one-year sentence.

A Miscellany of Malefactors

As the county seat for over two hundred years, Dedham has played host to multitudes of Norfolk County citizens seeking justice or paying the price for their infractions. The accused and the acquitted, the convicted and the incarcerated have all found themselves in the town's courts and jail, occasionally leaving behind a memorable tale. What follows is a selection of these tales, the first one illustrating that even in the shadows of the halls of justice, it is sometimes necessary to take the law into one's own hands.

On January 13, 1820, a barber living in Dedham Village received this note from a painter with whom he had once boarded: "Sir—from the many insults received, and attempts made on my life by you, I cannot rest easy until I get satisfaction: and as I am about to leave Dedham, it does hurt my feelings (though mean indeed) to fight with a barber. So I shall expect to meet you in half an hour from this time, at the back of Mr. C's shop."

The barber responded: "Your challenge is accepted. I will meet you at the time and place appointed. My life, my honour shall pay, or yours shall be my sacrifice."

Just after sunset, the men arrived in a back alley in the village along with their "seconds," or backups, to settle the quarrel with a pistol duel. After stepping off the traditional number of paces, the two men turned and faced each other. The painter fired his pistol, and the barber fell immediately, apparently mortally wounded. He was taken away to a nearby surgeon's by his second and several bystanders who had appeared on the scene after hearing the shot. The painter fled the scene in a panic, realizing too late that his pride had caused him to commit cold-blooded murder.

The following morning, as the story of the barber's demise was spreading through town, citizens were shocked, and ultimately relieved, to find him alive and none the worse for wear! In a clever ruse designed to both satisfy the honor of the painter and end the argument without bloodshed, the barber and the two seconds had contrived to load the pistols with powder only. An inspired theatrical performance by the barber at the crack of the pistol was

convincing enough to send the challenger on his way, leaving the perpetrators of the trick with an entertaining tale to share for years to come.

Sacco and Vanzetti were not the first anarchists to spend time in the Dedham jail. Ezra Heywood, abolitionist and advocate of personal liberty, was sentenced to two years' hard labor in the jail following his conviction on obscenity charges in 1879. Prior to the Civil War, Heywood had become actively involved in the antislavery movement with William Lloyd Garrison, Wendell Phillips and other noted abolitionists. After the war, he turned his attention to other radical causes, including equal rights for women. He and his wife published pamphlets from their home in Princeton, Massachusetts, advocating free speech, free trade and free love.

"Free love" in the 1860s did not mean the same thing as it did in the 1960s. In fact, Heywood promoted monogamy but insisted that men and women should be allowed to enter into love and, accordingly, sexual relations willingly and without government regulation. To ensure that all children were "wanted" by both parents, Heywood advocated birth control, albeit natural birth control by abstinence during a woman's fertile period. These views were outlined in a pamphlet he published in 1877 entitled *Cupid's Yokes*. The pamphlet caught the attention of Anthony Comstock, national crusader against obscenity, who in 1872 founded the New York Society for the Suppression of Vice and later lobbied Congress to pass strict anti-obscenity laws. Comstock thought *Cupid's Yokes* to be disgusting and "too foul for description." He used his power as a special postal inspector to have Heywood arrested at a free love rally in Boston for violating the obscenity laws by sending a copy of the "loathsome" pamphlet through the U.S. mail.

Heywood was sentenced to two years' hard labor, although a liberal judge allowed him to choose where he would serve his time. He chose the Norfolk County Jail in Dedham, where he began serving his sentence in June 1878. There, the forty-nine-year-old Heywood worked ten-hour days fitting cane bottoms onto chairs. He was respected by his jailers and often engaged in long conversations with Sheriff Woods. He received "a peck" of mail each day and continued the publication of his liberal newspaper while still behind bars.

Heywood's supporters did not forget him while he was in jail. On August 1, 1878, several thousand of them held a rally in Faneuil Hall, defending free speech, sharply criticizing the anti-obscenity laws, calling for Anthony Comstock's resignation and urging President Rutherford B. Hayes to pardon Heywood. The outcry did not fall on deaf ears; on December 19, Heywood

The Norfolk County (Dedham) Jail, about 1920. *Author's collection.*

was pardoned by President Hayes. The same judge who had sentenced Heywood signed the application for pardon.

Incarceration did nothing to dampen Heywood's radical spirit; in fact, it gave him yet another cause to rally for: prison reform. In a speech given at the Music Hall in Boston the February following his release, Heywood told the enthralled crowd: "When I stepped over the threshold of Dedham Jail, I stepped from the civilization of the nineteenth century into the barbarism of the tenth century." He then proceeded to describe in detail his experiences at Dedham while sharply criticizing the system that had sent him there.

Heywood spoke with compassion for his fellow inmates, who often felt as though society viewed them as nothing more than "a parcel of wild beasts carried about by Barnum." He told the story of two eighteen-year-olds serving five-year sentences for stealing twenty-six dollars' worth of hens—after having been enticed into perpetrating the crime by a state detective!

For Sheriff Woods, Heywood had only kind words, having earned the respect and trust of the lawman through long philosophical discussions. During one of these conversations, tears streaming down his face, the sheriff remarked to Heywood, "If I could have my way I would open the prison doors and say 'Go in peace and sin no more!'"

Over the next few years, Heywood continued crusading for his causes by lecturing, publishing and even serving more jail time. His last incarceration

lasted two years, weakening his health. Ezra Heywood died of tuberculosis in 1883. His efforts had little impact on the Comstock laws, which remained in effect in several states (including Massachusetts) until 1965.

Dedham Patrolmen Smith, Hatch and Crocker were lying in wait on an August afternoon in 1906, on the lookout for "scorchers," or speeders, making their way down Washington Street. Eventually, they pulled over a car barreling down the road at thirty miles an hour and discovered that the driver was William K. Vanderbilt, great-grandson of railroad tycoon Cornelius Vanderbilt. The twenty-eight-year-old Vanderbilt was making his way from Boston to the family's "cottage" in Newport, accompanied by his wife and a mechanic. Just one week earlier, Vanderbilt's brother had been stopped for scorching on the same stretch of road.

Vanderbilt protested that he was only going twelve miles an hour, after being warned about the speed trap by a driver in West Roxbury, but his reputation as a scorcher and his well-known hobby of racing cars contradicted his story. He vowed to return the following week and fight the charge. On the day of his scheduled court appearance, a large crowd had gathered to catch a glimpse of the young society dandy. But they were disappointed when Vanderbilt's lawyer arrived at court alone and paid the fifteen-dollar fine.

Bettina Masserelli was an attractive twenty-eight-year-old actress and singer from Dedham who turned to crime in 1928. In December of that year, she and a male accomplice robbed a grocery store clerk in Everett. As the clerk pleaded for the robbers to leave his "bread money" in his pocket, Masserelli told her accomplice to "sock him," which he did, breaking four of the clerk's teeth. As they were locking the unfortunate clerk in a coal closet, Masserelli told him that he was lucky to be alive.

Masserelli was arrested and her "marked attractiveness" and "sweet voice" helped the clerk identify her in court, where she was found guilty of armed robbery and sentenced to fifteen years at the Women's Reformatory in Framingham, the first woman in Massachusetts to be convicted of that crime. In August 1929 she made a daring escape from the prison by sliding down a rope made from bed sheets. A massive search was initiated for the escapee, and Dedham police were put on alert. Several days later, Masserelli was spotted in town riding in a car driven by a male companion, and a wild chase began through the streets of Dedham. The desperate woman leaped from the moving car and was eventually found by police hiding behind a stone wall. She was returned to Framingham to face an additional charge of felonious escape.

Divorce proceedings are routine at the Dedham courthouse, and for many years the personal, sometimes tragic, sometimes comic, details of these proceedings were regularly reported in the local papers. One particular case from the 1930s featured a Boston music legend as a witness.

In 1937, Ernest Panenka of Brookline was seeking a divorce from his wife Rosa. Panenka, the talented first bassoonist with the Boston Symphony Orchestra, contended that his wife had tried to sabotage his musical career. To back up his claim, Panenka enlisted famed BSO director Serge Koussevitzky as a witness. Because he was touring in Europe at the time of the hearing, Koussevitzky filed a deposition in support of the musician. In the deposition, he stated that Panenka's recent poor performance and frequent sour notes were signs of a troubled home life. If his marriage troubles weren't resolved and his playing didn't improve soon, Koussevitzky asserted, Panenka would lose his job. Panenka described how his wife would intentionally distract him while he was practicing at home by whistling, slamming doors, smashing dishes and tearing up artworks that he had created. The divorce was granted.

The People's Court

In July 1989, five episodes of the popular television show *The People's Court* were filmed in the same courtroom where Sacco and Vanzetti, the Millen brothers, Abraham Faber and countless others had placed their fates into the hands of a jury of their peers. There, Judge Joseph Wapner presided over "The Case of the Smelly Throw Pillows" and "The Case of the Bad Windshield Replacement," among others.

Chapter Four

A CINDERELLA ON HIGHLAND STREET
AND OTHER LITERARY LINKS

Although the next tale reads as if it were lifted directly from the pages of a Victorian romance novel, the events as described occurred in a Dedham home in the winter of 1851. A young girl from a learned and gentle but struggling Boston family volunteered to help her family's financial situation and "go out to service" for a respected lawyer as a light-duty maid and companion to the man's sickly sister. Soon after arriving, however, the girl realized that the "light duties" included scrubbing floors, shoveling coal, splitting wood and fetching water from the well. It also became clear that it was the elderly gentleman who desired companionship more so than the sister, and his attempts at conversation and social intimacy with the girl left her feeling a little uncomfortable. After seven weeks in the role of Cinderella, the young woman finally left and returned home to Boston with only a few dollars to show for her nearly two months of misery. The entire incident would have gone unrelated had not the girl gone on to achieve success as one of America's most celebrated nineteenth-century writers, Louisa May Alcott.

In the winter of 1851, the Alcott family was living in near destitution in Boston, the failed communal experience of Fruitlands behind them and Louisa's success as an author yet to come. While her father Bronson pursued a variety of writing projects and lecturing opportunities, Louisa's mother Abba had set up an "intelligence office," procuring work for the city's poor. One day, a distinguished gentleman entered the office, seeking to employ a young woman as a companion to his ailing sister. The job would require a bit of light housework but, moreover, would supply the employee with an

educational and uplifting experience in a fine home filled with books, music, artwork and good company. The gentleman was the Honorable James Richardson of Dedham, president of the Dedham Mutual Fire Insurance Company, onetime law partner of Fisher Ames and member of many of Dedham's most respected civic and social organizations.

The position as described by Richardson so intrigued and excited Louisa that she volunteered herself for the job before her mother even had a chance to consider an appropriate applicant. While maid's work might have seemed degrading to a member of the educated if not prosperous Alcott family, Louisa believed that idleness was even more shameful than going into service, and the energetic eighteen-year-old was restless and eager to do *something*.

To ward off the doubts and teasing of her sisters, Louisa envisioned herself the heroine in a gothic novel, and her arrival at the house on Highland Street did nothing to destroy the fantasy. In one of his many letters to Louisa prior to her arrival, Richardson had described the home as stately but decrepit. The same could have been said about the occupants. Richardson's sister Elizabeth, though only forty, was frail and inflicted with neuralgia, and so shy that she seemed in no desire or need of a companion. Consequently, Louisa found herself with considerable amounts of leisure time, which she would have happily filled with housework once she caught on to her employer's plans for the use of that time. Louisa was often invited into the study of Mr. Richardson, where he would read poetry to her for hours on end. He considered the young girl a confidante and shared with her not only his philosophical and intellectual musings, but also his personal struggles and feelings. When not engaging Louisa in these "therapy" sessions, he recited poetry to her while she performed the increasingly difficult household duties. This image of a needy, attention-starved romantic traipsing after his teenaged maid is in sharp contrast to that of the respected civic and business leader who had delivered an address before President Jackson some twenty years earlier.

When Louisa could stand it no more, she reminded her employer that the job required her to be a companion to his sister, not him, and that she would rather do housework than listen to his "philosophical, metaphysical and sentimental rubbish." She got her wish as the vengeful Richardson added more and more chores to the long list of duties, until Louisa was practically running the house herself. She wrote her mother in desperation, requesting a replacement, and although Abba complied by sending two different girls to take over the assignment, neither stayed long enough to allow Louisa to escape. Finally, after seven weeks, Louisa mustered the courage to quit the Richardson household.

Unfortunately, the ordeal did not even allow Louisa the small satisfaction of at least helping out with her family's troubled finances. During the short walk to the railroad station in Dedham Center, Louisa opened the envelope that had been handed to her by Mr. Richardson. Inside, she found the insulting amount of just four dollars, which Alcott family tradition holds was mailed back to the gentleman lawyer in a gesture of contempt. Louisa's account book for that day, however, shows the payment as income.

Louisa wrote a fictionalized account of her time in Dedham, entitled "How I Went into Service," and submitted it to Mr. James Fields, a prominent Boston publisher, who rejected it outright while advising Louisa to give up any thoughts of ever being a writer. It was finally published some twenty-five years later with the names of the Richardson household members slightly altered.

One can only wonder if during her weeks of misery, Louisa was aware that she was only blocks away from the childhood home of one of her favorite teachers. A few doors down from the Richardson home lived the family of James Foord, former Norfolk County clerk and associate of James Richardson. His daughter, Sophia Foord, had taught in the Dedham Middle School in 1833 before joining a transcendental community in Northampton, Massachusetts. It was there that she most likely met Louisa's father Bronson, who convinced her to come back with him to Concord to teach in a school that he was forming. Although the school never materialized, Sophia moved in with the Alcotts in 1845 in their recently purchased home they called Hillside.

Miss Foord was a creative and well-liked teacher, and her methods caught the attention of Ralph Waldo Emerson, who hired her to teach his children as well. During her stay in Concord, she made the acquaintance of Alcott family friend and frequent Hillside visitor Henry David Thoreau. Despite being fifteen years his senior, she was smitten with the young transcendentalist and made little effort to hide these feelings. In fact, she actually proposed marriage to a stunned Thoreau, whose response was recorded in this 1847 letter to Emerson, who was in London at the time:

> *I have had a tragic correspondence, for the most part all on one side, with Miss _____. She did really wish to—I hesitate to write—marry me—that is the way they spell it. Of course I did not write a deliberate answer—how could I deliberate on it? I sent back a distinct No, as I have learned to pronounce after considerable practice, and I trust this No succeeded. Indeed*

I wished that it might burst like hollow shot after it had struck and buried itself, and make itself felt there. There was no other way. I really had anticipated no such foe as this in my career.

Emerson's advice to Thoreau was to move forward and agree to never again mention the incident. As for Sophia Foord, she was heartbroken over the rejection and continued to carry a torch for Thoreau for many years afterward. In her later years, she kept correspondence with Louisa May Alcott and received a detailed description of the final days and burial service of Thoreau after his death in 1862. She lived out the rest of her life in Dedham with her sister Esther, where she died in 1885, and was buried in Brookdale Cemetery. Although Louisa May Alcott had lost touch with Foord during the last years of her life, she was sufficiently moved by her death to write a letter of tribute that was published in the *Women's Journal* magazine in April 1885. In part, Alcott's tribute read:

Sophia Foord was one of those who, by an upright life, an earnest sympathy in all great reforms and the influence of a fine character, made the world better while here, and left a sweet memory behind her. The warmth and vigor of her own nature were most attractive, and sincerely made her friendship worth having, and her lifelong desire for high thinking and holy living won for her the regard of many admirable persons, of whom she was too modest to boast.

The Silent Treatment

First published over one hundred years ago, Lucy Maud Montgomery's classic novel *Anne of Green Gables* has been a favorite of both adults and children ever since. The book was followed in quick succession by three others set on Prince Edward Island in Canada: *Anne of Avonlea* in 1909, *Chronicles of Avonlea* in 1912 and *Anne of the Island* in 1915. The title character of Anne Shirley is a precocious, red-headed orphan girl who wins the hearts of the elderly Marilla Cuthbert and her brother Matthew. In the summer of 1919, the RealArt Pictures Corporation purchased the rights to the books from Montgomery and began planning a "photoplay," or silent movie adaption, of the series. A scout was sent to New England to find suitable locations for filming, and after making his way to Dedham, he declared it to be exactly the

The Ernest Webb farmhouse on Prince Edward Island, inspiration for the fictional Green Gables. *L.M. Montgomery Collection, University of Guelph.*

"quaint New England village" they were looking for and the centuries-old Fairbanks House to be perfect as the title house. Period postcards and photos from Dedham confirm the town's charm and quaint rural character, but the selection of the Fairbanks House is puzzling, as it bears no resemblance to the bright white farmhouse that Montgomery used as her inspiration for Green Gables.

Sheet music for the 1919 film *Anne of Green Gables.*
Author's collection.

Starring as Anne Shirley was Mary Miles Minter, making her debut with Paramount Pictures after signing a contract to do twenty films for the company. At seventeen, Minter was already the veteran of thirty-four films, having started in silent pictures at age nine. Mary, whose real name was Juliet Reilly, was a blue-eyed, fresh-faced beauty with golden curls rivaling those of "America's Sweetheart," Mary Pickford. The role of the spirited orphan Anne was typical of the sweet, innocent and sometimes plucky characters Mary portrayed throughout her career. Accompanying the actress in Dedham, as she did on all location shoots, was her mother, Charlotte Shelby, who had considerable influence over Mary's career and the roles she played.

Anne of Green Gables was the first collaboration between Mary and director William Desmond Taylor. The handsome, forty-seven-year-old Taylor was a former actor and respected Hollywood figure. He arrived in Dedham with the crew at the end of July and began filming outdoor scenes at the Fairbanks House and various other familiar Dedham sites. Locations used in the final print of the film included the First Church, St. Paul's Church, the Endicott schoolhouse, the lawn of the Endicott Estate, the Captain Onion House, the Dedham Woods and the Charles River.

Production took longer than the director had hoped, due to an unusually rainy summer. While filming a scene at a grocery store in Islington, Taylor was heard to encourage the actors to "look serious; if you don't the whole morning's work has gone for nothing."

Toward the end of August, filming wrapped, and the cast and crew celebrated with a picnic at the Fairbanks House. Mary spoke at the Fairbanks family reunion and presented the newly elected president of the Fairbanks Foundation with a bouquet of American beauty roses. According to the

A Cinderella on Highland Street and Other Literary Links

Mary Miles Minter in a scene from *Anne of Green Gables*; the Fairbanks House can be seen in the background. *L.M. Montgomery Collection, University of Guelph.*

Transcript, the beautiful movie star "won the hearts of all who came to know her during her stay in Dedham."

The residents of Dedham could not have known at the time that they had witnessed the beginnings of a decidedly one-sided romance that would have disastrous consequences for all parties involved. Despite their thirty-year age difference, Mary Miles Minter had fallen deeply in love with her dashing director during their time in Dedham. In later interviews, Mary stated that she fell in love with Taylor the minute she met him. After each day's filming was over, the teen took every opportunity she could to be near him, much to the dismay of her mother. Mary stole moments with Taylor in the parlor of the little hotel in which they stayed and on their trips into Boston theatres. Taylor was apparently bemused by the infatuation and was unconcerned about any possible consequences.

On December 1, *Anne of Green Gables* was shown in Memorial Hall, which stood at the site of the present police station and was often used for screening motion pictures. Residents filled the hall for two shows that week and an additional two shows the following week. There was plenty of excitement during the screenings whenever the audience caught a glimpse of one of the seventy-five Dedham residents used as extras, or when James Burke's Jersey cow and Arthur Benson's "prize porkers" appeared on screen. Contemporary reviews of the movie were generally positive: "The story is replete with freshness and wholesomeness so often lacking in pictures at the present time. There is nothing naughty or wicked about this picture, simply a lightness and charm which cannot but make it enjoyable for everyone," read one newspaper review.

One viewer who was not so pleased with the film was the author of the series that inspired the movie, L.M. Montgomery. She was incensed that a schoolhouse scene included an American flag and that a skunk was introduced

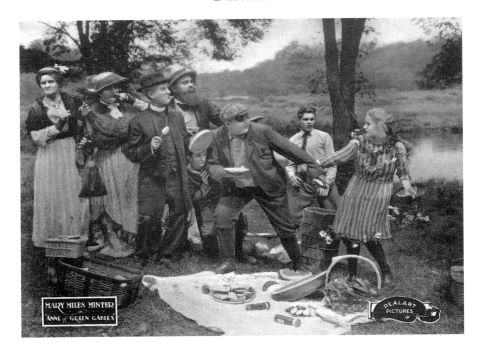

Lobby card from the 1919 film. *Author's collection.*

into the storyline, as skunks did not inhabit Prince Edward Island at the time. After viewing the film in a Toronto theatre in February 1920, Montgomery wrote in her journal, "It was a pretty little play, well photographed but I think if I hadn't already known it was from my book, that I would never have recognized it. The landscape and folks were 'New England,' never P.E. Island. Mary Miles Minter was a sweet, sugary heroine, utterly unlike my gingery Anne." She thought that the inclusion of an American flag was nothing but "crass, blatant, Yankeeism."

Nobody who attended the film could have known the tragedy and scandal that would befall its principal players in just a few years. On February 1, 1922, director William Desmond Taylor was found shot to death in his Los Angeles apartment. Within days, theories and suspects were being discussed by movie fans across the country. The suspect list included comic actress Mabel Normand, who was the last person to see the director alive; a former servant who may have been stealing regularly from Taylor; Charlotte Shelby, mother of Mary Miles Minter, who was unhappy with the relationship that her daughter had developed with the forty-nine-year-old director; and even Mary Miles Minter herself. Love letters to Taylor written by the nineteen-year-old actress

were found in his apartment. Many people had heard Mary say that she was engaged to Taylor and hoped to marry him someday. Mary was questioned by police, and the contents of her letters found their way into newspapers and movie magazines, where they were read by shocked and disapproving fans. Soon, theatres across the country began cancelling showings of her films.

Neither Mary nor her mother was ever officially named as a suspect, but the bad publicity and negative fan reaction sent them into seclusion soon after the murder, and Mary's career in Hollywood was over. Some fifteen years after the murder, the former actress and her mother appeared before a grand jury to answer questions about Mary's relationship with Taylor. Diary entries written during the filming of *Anne of Green Gables* were revealed, attesting to her love for Taylor and her desire to one day marry him. After the hearing, Mary faded from the public eye for good. After spending some time in Paris, she returned to the United States and lived the rest of her life in seclusion before passing away in 1984 at the age of eighty-two.

Of the fifty-two silent movies Mary made in her career, only six are known to survive. Unfortunately, *Anne of Green Gables* is not one of them. It is believed that copies of Minter's films were destroyed by disapproving theatre owners and distributors. The murder of William Desmond Taylor was never solved and remains one of Hollywood's most intriguing mysteries. Historians and silent film buffs hope that the continued interest in the murder case and the never-waning popularity of the Avonlea books will someday lead to the discovery of a dusty set of film canisters in some long-forgotten attic or storeroom, as was the case with several original movie posters from the 1919 film that were found under a carpet in a home in Michigan and are now residing in the National Library of Canada.

Dedham's other noteworthy house, the Endicott Estate on East Street, had a cameo in the *Anne of Green Gables* film, with several scenes being shot on the lawn. Some eighty years later, the 1905 mansion got another chance at Hollywood fame when a film crew arrived in Dedham in the fall of 1999 to shoot scenes for the David Mamet comedy *State and Main*. The mansion's interiors were used to represent a Vermont inn. In an eerie coincidence, the movie shares a storyline with the real life events that took place during the 1919 filming in Dedham. In the movie, a Hollywood film crew arrives in a small New England town and its citizens get wrapped up in the drama both on and off the screen. There is even a plot point in which the character played by Alec Baldwin becomes romantically involved with the much younger character played by Julia Stiles, with disastrous results.

Motion picture fever still gripped the town six months after the first showing of *Anne of Green Gables*. In June 1920, a movie company set up on Dedham Common to make a film version of the Longfellow poem "The Bell of Atri" for the Humane Society of Boston. Longfellow's poem concerns the village of Atri in Italy, where a bell was hung by the king for any citizen to ring whenever a wrong had been committed. The king appointed a judge who would respond to the call of the bell and listen to the petitioner before deciding a proper course of justice. A greedy knight in the town was well known by residents for his continued abuse and neglect of his trusty horse. Early one morning, the judge was awakened by the loud pealing of the bell and ran to the marketplace to see who was demanding justice. When he arrived at the town square, he was startled to see the knight's worn-out horse clenching the bell's rope in its mouth! A large crowd soon gathered and attested to the mistreatment of the horse by the uncaring knight. The judge ordered the knight to take care of the horse until the end of his days, and the townspeople triumphantly led the steed back to its stall.

Although the horse was the real star of the film, several hundred extras, or "supes" as they were called, streamed into Dedham for the filming. Memorial Hall was used as a changing room for the supes, who put on eighteenth-century silk dresses and powdered wigs before walking down High Street to the common. Many of the main players in the film ate lunch at the Dedham Inn while the extras had a picnic on the common.

The Bell of Atri was used as part of the MSPCA's "Be Kind to Our Dumb Animals" campaign and was shown to students and civic organizations across Massachusetts. A copy of the movie was stored in the MSPCA's archives until it was destroyed in a fire in 2008. The adaptation of Longfellow's poem for the movie was written by Dedham resident Ethel Howard Lincoln, whose mother, Doris Howard, was principal of the Avery School for many years.

The Friends of Eddie Coyle

Published in February 1972, *The Friends of Eddie Coyle* was the first of several dozen crime novels written by Boston lawyer and onetime state assistant district attorney George V. Higgins. In the gritty, realistic tale, told mostly through dialogue, Eddie Coyle, a middle-aged, low-level criminal, tries to make a deal with authorities in order to avoid an impending prison sentence. The novel was well received by critics and

almost immediately picked up by Paramount Pictures. Filming began in the Boston area that fall, with the title character being played by veteran film noir actor Robert Mitchum. Director Peter Yates shot the entire movie, including interiors, on location in the Greater Boston area in order to give the film the same realistic feel as the novel.

While neither the book nor the movie mentions Dedham specifically, longtime residents will immediately recognize the town's 1972 incarnation right from the movie's opening shots. Actors and crew members first came to town on October 17, filming a scene at the Dedham Plaza. Over three hundred excited fans gathered to watch the filming and get a glimpse of Hollywood legend Mitchum, who obligingly signed autographs between takes. The final version of the scene offers a panoramic view of many of the Plaza's long forgotten businesses: W.T. Grant's, Woolworth's, Barbo's Furniture, Liggett's Drugstore and Capitol Supermarket, as well as retail survivors Friendly's and Plaza Liquors. The crew returned to Dedham on December 1 to shoot the film's opening sequence, a dry run of the robbery of the South Shore National Bank on the corner of Bryant Street and Eastern Avenue. The camera follows a car being driven by the bank manager as it passes longtime Dedham Square businesses Geishecker's, P.J.'s Pastry Shop, McLellan's and Gilbert's Package Store. As the car turns into the parking lot of the bank, town hall and the rear of the Community Theatre are visible in the background. The robbery was shot inside the bank building.

Paramount Pictures included some interesting promotional suggestions in its press kit for the movie, many of which sound as if they came right out of the Girl Scout handbook rather than from a sophisticated Hollywood marketing machine. Theatres and radio stations were encouraged to run various promotions, including trivia contests, a Robert Mitchum look-alike contest and a "strong box" promo. The strong box promo required theatre owners to keep a safe in the lobby and invite patrons to crack it for a fabulous prize (locksmiths, naturally, were ineligible). Other ideas included giving free movie tickets to anyone named Coyle and having local pubs serve a special drink called a "Coyle-r-maker."

Although hailed by many as the best Boston-based film ever made, *The Friends of Eddie Coyle* was not released on DVD until May 2009. Less than a month later, a robbery attempt at the same Dedham bank building on Bryant Street had locals recalling the film and wondering if it had perhaps even inspired the would-be robber. On the morning of June 16, 2009, a man dressed in a suit and tie entered the Citizen's Bank branch at about 8:40 a.m., the same time as the film bandits, who had to wait patiently until the

automatic vault opened at 8:48. Once inside, the man waved a gun around and ordered the bank employees to sit on the floor, just as the robbers had done in the movie. In contrast to his movie counterparts, who pulled off a successful heist, this robber was foiled by technology that did not even exist when the 1972 movie was filmed. A bank manager sent a text message to a manager at another Citizen's Bank branch, who in turn called Dedham Police. Two officers who were working a detail just yards away on Eastern Avenue arrived and arrested the suspect.

Chapter Five

HORSE TALES AND OTHER ANIMAL TALES

It is probably safe to say that a twenty-first-century child growing up in Dedham is more likely to see a deer in the backyard eating the rhododendrons before ever laying eyes on a horse. Over time, the horse has become as exotic as the "learned elephant" that came to town so long ago. These horse tales recall a time in Dedham's past when the sight (and smell) of a horse was a familiar one on the streets and in the fields of town.

Stop, Thief!

Horses were the hardest workers in nineteenth- and early twentieth-century America. They carried citizens and soldiers and pulled plows, delivery and fire wagons, carriages, coaches and streetcars. They raced and chased the fox and the polo ball. A whole equine industry developed around the animal, employing stable hands, livery workers, blacksmiths and, of course, thieves. While the highwayman of old was often romanticized in verse and song, the horse thief was regarded with as much loathing as the modern carjacker is today.

In 1810, the citizens of Dedham were determined to put an end to the horse thievery that had recently plagued the town. Meeting in Marsh's Tavern, a group of men founded an organization that would eventually become known as the Society in Dedham for Apprehending Horse Thieves. The need for such an organization is described in the preamble to the constitution, printed in 1816:

From the great number of Horses stolen in this part of the country, it is evident there has been a combination of thieves to carry into execution this felonious design. As horses are a kind of property easily carried out of our knowledge, the thief often escapes the hand of justice, and is thereby encouraged to continue the heinous practice of Horse-stealing, and with it a train of other enormities ever associated with that crime. The existence of such combinations, or the frequent escape of thieves with impunity not only endangers the property of individuals, but has a direct tendency to contaminate the community at large. Hence, to prevent these evils, is an object entitled to the aid of every well disposed citizen.

The problem was apparently widespread, as similar societies were formed at around the same time in nearby Brookline, Roxbury, Newton, Milton, Needham, Medfield and Milford.

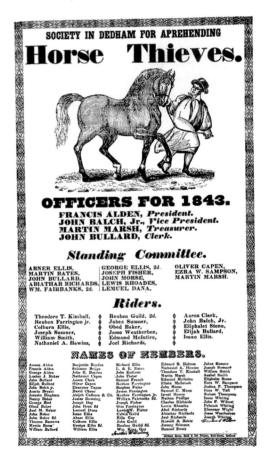

An 1843 poster for the Society in Dedham for Apprehending Horse Thieves. *Dedham Public Library.*

The constitution's bylaws stipulated that only citizens of Dedham could apply for membership, and only horses stolen within twenty miles of the Dedham Courthouse would be pursued. Member dues were used for expenses occurred during the hunt, which could include rewards, printing costs for posters and fees for newspaper advertisements such as the following from the *Village Register*:

> *Twenty Dollars REWARD!!!*
> *STOLEN,*
> *From the Mr. Mason Richard's Store, in Dedham, on the evening of Tuesday the 17th instant, a dark bay HORSE, about ten years old, switch tail, a good traveler, trots square, has a large bunch on his under jaw. ALSO a green bodied bellows-topped CHAISE, having the carriage part Yellow, small glass behind, and an iron axle tree. Whoever will return the said Horse, Chaise, and Thief shall receive the above reward or half the same for either.*
> *Reuben Richards, Josiah S. Fisher, Jonathan H. Cobb*
> Committee of the Society for Apprehending Horse Thieves
> *Dedham, December 20, 1822*

In its early years, the society proved its usefulness by making several successful recoveries. When a member of the prominent Farrington family reported his horse stolen in 1826, a group of riders quickly set out on the road west after the thief, only to find the horse grazing peacefully by the side of the road in Natick. Because no theft had actually occurred, Farrington was obliged to cover the cost of the hunt over and above his annual dues of twenty-five cents. Another chase in 1840 led the riders south on Providence Road, where they found evidence that the thief had been thrown into the mud before making his getaway. The horse was recovered from a nearby farmer and returned to John Fisher, the owner.

By the 1880s, although membership was still strong, the society had outlived its usefulness. Many of the other societies in the area had disbanded, and Dedham's was being touted as the oldest of its kind in the country. This claim was disputable, however, as the Milford Society founded in 1795 was still in existence.

Several important changes to the bylaws were enacted during the presidency of Dr. Edward Knobel, assuring that the organization would continue on. At the annual meeting in 1900, members voted to make each year's meeting a social event and to hold a banquet. From then on, committee

ANNUAL MEETING

The Society in Dedham for Apprehending Horse Thieves

Monday Evening, Dec. 5, 1921, Memorial Hall, Dedham, Mass.

BANQUET 6.30 SHARP. TICKETS $2.00 PER PLATE

Annual Reports. Election of officers. Applications for Membership.

BEST ENTERTAINMENT EVER OFFERED TO MEMBERS

YARRICK, clever magician and humorist (with us five years ago); CONANT, pianist and breezy song leader; LINDEN, with a bagful of new character stories.

SONG SHEET ALL THE EVENING

Tickets can be obtained from the clerk and other officers, and at drug stores in Dedham, East Dedham, Norwood, Westwood and Islington, also from Albert Fales, Norwood, W. Hooper, Islington, and H. Bonney, Westwood.

As there are now more than 600 members, seats will be reserved only for those returning the attached Return Card.

FREDERIC C. COBB, Clerk. E. DWIGHT FULLERTON, Pres.

An unused ticket to the 1921 annual meeting. *Author's collection.*

reports and the swearing in of officers and riders were followed by musical entertainment, comedy or magic. One tradition begun around this time was the election of the heaviest member as a rider. For several years, this honor went to 350-pound Ralph Cheever, who served as president from 1919 to 1920. In 1902, membership was expanded to include citizens living in all of Norfolk County, and a twenty-five-dollar donation to the Dedham Emergency Nursing Association began a long tradition of charitable giving.

In contrast to this light-hearted jocularity, horse thievery was still pretty serious business in other parts of the country, and many a thief was tracked down and hanged by vigilantes. The Dedham group had another chance to prove its worth when a horse was stolen from Scarry's Livery Stable in July 1906. The society members did their best to find the horse, but with no luck. It was rumored that the theft had been perpetrated by a well-known thief from Rhode Island.

Four years later, Scarry's widow and several stable hands were excited when Joseph Agel of Boston brought a horse into the stable on Eastern Avenue. The horse appeared to be the same one stolen four years earlier. Police were called in by both parties, and in December 1910, they found themselves in the Dedham court to settle the dispute. Mrs. Scarry testified that she recognized her property immediately, describing the horse as short, chunky, blind in one eye and nervous, which leads one to wonder what all the fuss was about.

In 1925, the Milford Society disbanded after 130 years of service, leaving Dedham the right to claim the title of the oldest such society in the country. New traditions have replaced the outdated ones, such as the sponsorship of celebrity memberships, including Elvis, the pope and each newly elected American president. Today, the society is as popular as ever as it begins its third century of vigilantly discouraging and apprehending those who would pursue "the nefarious practice of Horse-stealing."

Anna's Place

The Animal Rescue League of Boston was founded in 1899 by Mrs. Anna Huntington Smith, and within a few years two of its most important operations were located in Dedham. In 1907, the organization opened a rest home for horses on a fourteen-acre farm in the Riverdale section of town and named it Pine Ridge. One of the rescue league's main missions was to ease the suffering of horses that had been mistreated, neglected or just worn out from pulling cabs, express wagons and fire engines. Mrs. Smith was passionate about her work, and she and her staff veterinarian, Dr. Frank Sullivan, thought nothing of approaching cab drivers on the streets of Dedham or Boston and convincing them to hand over possession of their horses for rehabilitation and rest or, in some cases, humane euthanasia. Mrs. Smith could not stand to see an animal suffer for one moment more than need be, and oftentimes she would take a horse on its way to the slaughterhouse in Brighton and have it put down just to save it from walking those last few grueling miles. At Pine Ridge, she had an electrified stall built that allowed the horse to enter of its own accord where it would meet its merciful end. She called this device "the House of Blessed Release." Those horses that could be rehabilitated were kept at the farm for a few weeks of rest and returned to their owners with an admonition to take better care of the animal.

While the main function of the farm was the care of horses, kennels for cats and dogs were also built and adoption services were provided. Beginning in 1908, a visitors' day was held every spring. Visitors could tour the property while riding in a wicker carriage pulled by Beppo the donkey, a refugee from a park that had closed in Lexington. Often, children from the Riverdale School were invited to the bungalow of Mr. and Mrs. Smith, where, after feeding the horses apples and sugar, they were treated to a feast of their own complete with ice cream and a sing-along. The league set up a "bird

table" in the schoolyard of the Riverdale School, where seed, crumbs and suet were made available to the local bird population. As horses began to fade from the American urban and suburban landscape, Pine Ridge shifted its focus to the adoption of cats and dogs. In the 1980s, the league returned to its original mission when it established the Equine and Livestock Rescue, Rehabilitation and Adoption Program.

More than a Friend

Shortly after moving to Dedham, Mrs. Smith created the Pine Ridge Pet Cemetery on the wooded hills adjacent to the horse farm. Many beloved pets are buried here beneath stones that are sometimes elaborate, sometimes whimsical but always touching.

Some of the pets were once companions to Greater Boston's famous and infamous citizens. Serge Koussevitzky, Boston Symphony Orchestra conductor from 1924 to 1949, had his beloved pet buried here. In 1923, an elaborate mausoleum containing the remains of a Yorkshire terrier named Jessie was

Mausoleum for Jessie, built by R.H. White. *Photo by author.*

Gravestone for Lizzie Borden's dogs. *Photo by author.*

removed from the Chestnut Hill estate of department store founder R.H. White and rebuilt on the grounds of Pine Ridge. Three dogs once belonging to accused axe murderer Lizzie Borden are buried here. One pet interred at Pine Ridge, however, attained worldwide fame that rivaled that of his renowned owner. On the last day of May 1931, Admiral Richard Byrd came to Dedham from his Boston home to bid farewell to his beloved fox terrier, Igloo.

Admiral Byrd with Igloo. *Author's collection.*

Igloo had been a stray wandering the streets of Washington, D.C., in 1926, when an admirer of the admiral's rescued the pup and presented it to Byrd just prior to his departure for the North Pole. The animal-loving navy man gladly welcomed "Iggie" as part of the crew, and a deep bond formed between the two during the voyage north. After reaching their northern destination, Igloo watched as his master flew across the pole and into the history books as the first solo pilot to accomplish such a feat. Before they even returned from the trip, the admiral and the pooch had become international celebrities, and they were both treated to a hero's welcome upon their return to New York City in May 1927.

Byrd's next expedition took him and Igloo to Antarctica in 1928, where they set up a camp called "Little America." Byrd and his crew stayed for nearly two years conducting geological surveys and exploring the continent. Radio listeners and newspaper readers eagerly awaited news of both the admiral's and the terrier's exploits. While Byrd was making history as the first person to fly over the South Pole, Igloo was scampering across the ice chasing seals and penguins.

Back home, Igloo met both Presidents Hoover and Coolidge and traveled the country with his master on lecture tours. When not traveling, the pup lived with the admiral's five children in their home overlooking the Charles River in Boston.

In the spring of 1931, Admiral Byrd was on a lecture tour when he received a desperate message from his son back in Boston. Igloo had suddenly become gravely ill with a stomach ailment. Byrd had been scheduled to give two lectures in Tennessee before sold-out crowds that included the mayor, a senator and a bishop. The Arctic hero immediately suspended the tour and rushed home to Boston to be with his dying friend.

William Brigham, chairman of the Animal Rescue League, offered a burial plot for Igloo in the Pine Ridge Pet Cemetery. The services took place on May 31 with a small group of the admiral's family and friends gathered. The dog's small white coffin was carried to the grave by Byrd's personal secretary and a member of the South Pole expedition. Accompanying the admiral was his eleven-year-old son Dickie. Father and son each placed a spray of flowers on the grave when the service ended. A few months later, a large stone in the shape of an iceberg was placed at the grave. Carved below Igloo's name was the simple inscription "He was more than a friend."

Byrd received thousands of sympathetic letters from pet lovers across the country, many offering to give him another dog, but the grief-stricken admiral made it clear that Igloo "could not be replaced." In 1997, a statue

Igloo's stone at Pine Ridge Pet Cemetery. *Photo by author.*

of the polar explorer, his faithful friend Igloo by his side, was unveiled in his hometown of Winchester, Virginia. At the dedication ceremony, Byrd's seventy-seven-year-old daughter, Bolling Byrd Clarke, concluded her remarks about her famous father by saying, "I have a fantasy of him and Igloo kicking up dust investigating Mars and taking off in a space ship traveling between the stars and planets to the outer limits, searching for answers to the mysteries of the universe."

Mr. Ed with Alan Young and Connie Hines. *Author's collection.*

The main characters of this last equine tale include one of America's most recognized horses and a popular Dedham High graduate. The horse (of course) is the famous Mr. Ed, who charmed American television viewers on the popular sitcom of the same name from 1961 to 1966. Co-starring as Ed's owner and confidant Wilbur Post was Allan Young, and as Wilbur's perky wife Carol, Connie Hines, the most popular girl in her Dedham High class of 1948. After graduation, Connie worked as a secretary before trying

her hand at acting, a profession that had been practiced by both of her parents as well as her maternal grandmother. Connie moved to New York and did a few television commercials before heading out to Hollywood in 1959. After several guest roles in *Perry Mason, Sea Hunt, The Untouchables* and *M Squad,* she auditioned for and got the part of Carol Post in *Mr. Ed,* playing opposite Young and Bamboo Harvester, who played the talking horse. After the show's run ended in 1966, Connie stayed in television for a few more years, guest starring in shows such as *Mod Squad* and *Hollywood Squares* before retiring in the early 1970s.

In July 1961, Connie made a triumphant return to her hometown, where the red carpet was literally rolled out for her. Connie made her way to Dedham Square in the back of a convertible escorted by police. There, she met selectmen in front of Memorial Hall. She was given an honorary key to the town by officials, as well as a bouquet of roses by Ralph Eaton, Dedham High principal during Connie's years there. She later entertained old classmates at a poolside reception at the Hotel 128 before jetting back to Hollywood.

The Striped Pig

Temperance, by strict definition, means the moderation of an indulgence or passion, and the temperance movement of the nineteenth century began by advocating moderation of alcohol consumption. When church groups became involved in the movement, the focus shifted from moderation to total abstinence in order to preserve social, religious and family values. The American Temperance Society was founded in 1826, and within a short time the evils of liquor were being condemned at large rallies and in newspapers, songs and even children's storybooks. Temperance Party candidates were supported for public office, and local anti-liquor laws were adopted across the country.

In 1838, temperance advocates in Massachusetts helped to bring about the passage of the strictest anti-liquor law to date. Known as "the fifteen-gallon law," the ordinance stipulated that spirits could only be sold in quantities of fifteen gallons or more and must be taken away all at once. From the moment Governor Edward Everett signed the law, anti-temperance Whigs began working on its repeal while temperance-supporting Democrats defended it. While this legislation naturally put a

crimp in the activities of tavern keepers and their patrons, imbibers left the legal battling to the politicians and devoted their energies to devising clever ways to get around the law. One such scheme was put into practice at the Dedham military muster in the fall of 1838.

The annual muster was a much-anticipated event in Dedham, as much for its military action as for its traditional drunken revelry. In September 1838, local militia volunteers anxiously awaited the first muster to be held since the passage of the fifteen-gallon law, expecting a much more subdued event on the Dedham lower plain in Readville. A local vendor, however, had concocted a scheme that would slake the thirst of all while skirting the despised law. The vendor erected a tent on the field adorned with banners proclaiming the exhibition of a most unusual natural occurrence: a striped pig! For a mere six cents, patrons could witness the curiosity firsthand. A few brave souls paid their admission and headed into the tent, but the majority of the crowd was hesitant, afraid of being tricked out of their money. Soon, their curiosity got the better of them—they needed to figure out the mystery of the clinking of glasses coming from inside the tent as well as the unusual jollity of the exiting patrons. When the reluctant customers finally parted with their pennies and entered the tent, they were indeed treated to the sight of a large pig with suspiciously artificial stripes, but they also received an unadvertised bonus: a free glass of rum! The muster field was soon crowded with dozens of drunken, dancing soldiers.

Within days, the incident was reported in newspapers across the nation, and the "striped pig" phenomenon had begun. Public drunkenness was now known as "riding the striped pig." When a Tennessee law was passed forbidding the issuance of any more liquor licenses for taverns, a Baltimore paper declared, "The striped pig will beget no hogs in the west." Those opposed to the law formed Striped Pig political parties and had Striped Pig conventions, such as the one held at the Norfolk Hotel on Court Street a month after the muster. Temperance promoters adopted the new metaphor as well, including specific bans on "striped pig devices," or ruses employed to evade the law.

Two weeks after the muster, a popular music hall entertainer, Mr. Wills, introduced the song "Dedham Muster, or The Striped Pig." The song proved quite popular and was sung in many a music hall over the next few years. The following lyrics describe the scene in Dedham that hot day when greedy vendors charged such outrageous prices for water that thirsty soldiers turned instead to the tent with the striped pig banner flying from it:

The Striped Pig

In Dedham just now they'd a very great muster
Which collected the people all up in a duster
And a terrible time, and what do you think,
To find out a way to get something to drink.
A Yankee came in with the real nutmeg brand,
Who has sold wooden clocks throughout the land
And he hit on a plan a little bit slicker
By which he could furnish the soldiers with liquor.
They would not allow him to sell by the mug
Unless he could furnish a fifteen-gallon jug.
And so folks wouldn't drink in a measure so big
He got out a license to show a striped pig.
He thought he'd go snacks with the four-legged brute
That belongs to the genus that knows how to root
This fellow was taught, no doubt by the devil
The way to get at the root of all evil
In the sham fight there was a very great slaughter
And them that surviv's it they couldn't get water
For them that had wells for a quart ax'd a quarter
Which was a great sight more than they ever had orter
A doctor who wanted some patients to rob
Looked into the tent in search of a job;
Disease in the optics he could descry
For each one that went in had a sty in his eye.
A sailor came up under full sail,
Who said he chawed oakum in many a gale
He gave the porker a boisterous hail
And ask'd for a quid of his pig's tail.
A wealthy distiller next looked in,
To see how they turned their grain into gin
He dryly remarked after drinking his fill
That was a queer way of working the worm of the still.
A farmer rode by on his long-tailed steed,
To ask what they would give him for feed;
Said he'd a good stock of the Fifield bred
But such a striped pig he never had seed.
The sign at the tent was striped pig to be seen the Wonder of Dedham, this

four legged thing;
A four-penny bit they paid to get in
Which Piggy paid back in his brandy and gin.
The Temperance men they felt rather sore,
They thought the Striped Pig was a very great bore,
But they told the keeper they'd no longer rail
If he'd rig out his pig with a temperance tail.
The folks at the muster they all agreed
That this was the pig for crossing the breed
For he left his mark on every biped
That went in sober, but came out striped.

DEDHAM MUSTER; OR STRIPED PIG, AND ALICE GRAY.

Striped Pig,
As Sung with unbounded applause.
TUNE—King and Countryman.

IN Dedham just now they'd a very great MUSTER,
Which collected the *sogers* all up in a cluster,
And a terrible trouble about what, do you think?
To find out the way to get something to drink,
Ri tu, di nu, di nu, di nu, ri tu, di ni nu, ri ni, di nu, ri na.

A Yankee came up with the real nutmeg bran,
Who had sold wooden clocks throughout all the land;
And he hit on a plan, a *leetle bit slicker*,
By which he could furnish these *sogers* with liquor.
Ri tu, &c.

They would not allow him to sell by the mug,
Unless he could furnish a fifteen gallon jug;
And as folks would'nt buy drink in a measure so big,
He got out a license to show a striped pig.
Ri tu, &c.

He thought he'd go snacks with the four-footed brute,
That belongs to the genus that knows how to *root*;
For this fellow no doubt was taught by the devil,
This new mode to get at the root of all evil.
Ri tu, &c.

In the sham fight, there was a great slaughter,
And them that survived it couldn't get water;
For such as had wells, for a quart *az'd* a quarter,
Which was a darn'd sight *more* than they ever had *orter*.
Ri tu, &c.

A Doctor who was in search of some patient to rob,
Looked into a tent to find him a job;
Disease in the optics h z'd quickly espy,
For each one that went in, had a *sly* in his eye.
Ri tu, &c.

A Sailor came up who was under full sail,
Who said he'd chaw'd oakum through many a gale;
He gave the keeper a boisterous hail,
And *az'd* for a quid of his pig's tail.
Ri tu, &c.

287

A wealthy Distiller next looked in,
To see how the pig turn'd their grain into gin;
He drily remark'd, after drinking his fill,
'Twas a queer way of working the worm of a still.
Ri tu, &c.

A Farmer, who rode his long tail'd steed,
Came in to see what this pig had for feed.
He said that he'd a good stock of the Byfield breed,
But such a striped pig he never had *seed*.
Ri tu, &c.

"STRIPED PIG TO BE SEEN," as you all must know,
Was the sign at the tent—'twas quite the go;
A fourpenny bit they paid to get in,
Which piggy paid back in rum, brandy or gin.
Ri tu, &c.

The Temperance folks, they felt rather sore,
They thought the Striped Pig a very great *boar*;
But they *told* the keeper they'd no longer rail,
If he'd rig out his pig with a *temperance tail*.
Ri tu, &c.

The folks at the muster, they all agreed,
That this was the pig for crossing the breed;
For he left his mark on every biped,
For they went in sober, but come out striped.
Ri nu, &c.

Alice Gray.

SHE'S all my fancy painted her,
She's lovely, she's divine;
But her heart, it is another's,
She never can be mine.
Yet loved as man ne'er loved,
A love without decay;
Oh! my heart—my heart is breaking
For the love of Alice Gray.

Her dark brown hair is braided o'er
A brow of spotless white;
Her soft blue eye now languishes,
Now flashes with delight.
The hair is braided not for me,
The eye is turned away;
Yet my heart—my heart is breaking,
For the love of Alice Gray.

I've sunk beneath the summer's sun,
And trembled in the blast;
But my pilgrimage is nearly done,
The weary conflict's past.
And when the green sod wraps my grave,
May pity haply say,
"O! his heart—his heart was broken,
For the love of Alice Gray."

Sold, by L. DEMING, at the Sign of the Barber's Pole, No. 61, Hanover Street, Boston, and at MIDDLEBURY, Vt.

Lyric sheet for "Dedham Muster" song. *Library of Congress, Rare Book and Special Collections Division, America Singing: Nineteenth-Century Song Sheets.*

STRIPED PIG PARTY

LIBERAL

MEETING.

ALL who are opposed to the new License Law and in favor of its repeal, are requested to meet (without reference to political parties) at the Town Hall, on Monday evening, November 5th, at 7 o'clock for the purpose of *nominating* candidates to represent this Town in the next Legislature, and to organize with reference to the coming election.

Springfield, October 26, 1838.

THEODORE BLISS	STEPHEN C. BEMIS	M. PENDLETON
WELLS LATHROP	DANIEL LOMBARD	SOLYMAN MERRICK
JOHN HOWARD	JONATHAN DWIGHT JR.	W. W. ORNE
WM. DWIGHT	GILLETT HAWLEY	ALBERT MORGAN
GEO. COLTON	THOMAS DICKMAN	JEROME WELLS
HARVEY CHAPIN	JOSEPH CHAPIN	M. D. GRAVES
GEO. DWIGHT	RUEL VANHORNE	W. E. WENTWORTH
HENRY SEYMOUR	JAMES L. LYON	JAMES W. CROOKS
HARVEY HILLS	EDMOND VANHORNE	HENNING LEAVITT
C. PENDLETON	PLINEY CHAPIN	NATHANIEL HOWARD
C. W. CHAPIN	BINEA SPERRY	JOSEPH CHAPIN JR.
MAJOR GOODSELL	SIMEON CHASE	STEPHEN O. RUSSELL
JONA. GOLDTHWAIT	ELKANAH BARTON	ALBERT S. CHAPIN
LUTHER SPENCER	WILLIAM MILLER	JONA. CAPRON
EBENEZER WHITE	SETH STEBBINS	SAM'L. EASON
C. B. CHAPPELL	D. M. BRYANT	S. A. SHACKFORD
MERRICK MURPHY	OTIS CHAPMAN	MARTIN ADAMS
SILAS GOFF	GEORGE W. CULVER	RICHARD B. JOHNSON
ISRAEL PHILLIPS JR.	JOSEPH ROBINSON	JOSIAH STEVENS
MOULTON TAYLOR	WALTER PEASE	MARVIN CHAPIN
ARTEMAS ROGERS	VERANUS CHAPIN	ALPHEUS FERRY
A. WRIGHT	JOHN GIDDINGS	ASAPH TALMAGE
JOSEPH ASHLEY		

Advertisement for a meeting of the Striped Pig Party. *Library of Congress, Rare Book and Special Collections Division.*

Public houses began changing their names to "The Striped Pig," and the famous animal began appearing on tavern signs in Boston, causing residents to argue about the proper direction of the stripes. Like any fad, the striped pig excitement eventually faded, although as late as 1857 the name was still being used to describe any clever trick employed to get around a liquor law.

As for the fifteen-gallon law that sparked the whole incident, it was repealed in April 1840. Despite his promise to repeal the law, Governor Edward Everett was defeated by Marcus Morton in the 1840 gubernatorial election by one vote, becoming yet another victim of the striped pig.

A Bunny Tale

A whimsical bunny rabbit nibbling on a stalk of Brussels sprouts has helped to make the Dedham name well known across the country and around the world. The bunny, featured on various pieces of earthenware known as Dedham Pottery, made its first appearance over one hundred years ago, and is just as popular today with collectors who treasure both original and reproduction pieces of the pottery.

Reproduction Dedham Pottery vase. *Photo by author.*

The Dedham Pottery works began operating in town in 1896, creating its distinctive tableware in a factory off High Street. The company had been founded in Chelsea in 1859 by Scottish immigrant and master potter James Robertson. It was James's son Hugh who developed the distinctive crackle ware glaze and rabbit motif tableware that became popular with Boston's upper classes at the turn of the twentieth century. While the rabbit was only one of over fifty designs made, it became the overwhelming favorite and eventually became the symbol of the company. Many of the pieces were decorated by

the skilled hand of Maude Davenport, who grew up in Greenlodge and worked at the factory for almost twenty-five years.

The pottery was handmade in a factory on Pottery Lane until April 1943. At that time, Hugh's grandson, J. Milton Robertson, accepted a commission in the United States Navy and decided to close down the operation. The remaining stock, including rare museum pieces crafted by James Robertson in Chelsea, was liquidated through a half-price sale at Gimbel's department store in New York City. The Dedham Pottery factory building burned down in 1971. In 1977, the Potting Shed, Inc., began producing and selling Dedham Pottery reproductions, and whole new generations of collectors have since become enchanted with the simple little bunny.

Chapter Six

TRADITIONS

M ost of Dedham's holiday traditions have gone the way of the trolley tracks down Washington Street and are now nothing more than nostalgic episodes from the past. Some have been revived, while others were abandoned long ago, and with good reason. The annual Thanksgiving turkey shoot of days gone by is one holiday tradition that modern-day animal advocates would not be comfortable with, even after learning that the turkeys were already dead before being used as targets.

The Glorious Fourth

No American holiday has been as revered as Independence Day, so much so that eventually it became known simply as "the day we celebrate." From the very first celebrations in 1776, citizens across the country observed the day with festivities both dignified and bombastic. In early nineteenth-century Dedham, many of the town's most prominent citizens would gather at one of the local taverns and enjoy a sumptuous feast, followed by a reading of the Declaration of Independence and a series of toasts filled with patriotic fervor. In time, the "Glorious Fourth," as it was also called, would be celebrated with a much wider variety of activities open to all, including parades, concerts, races, bonfires and field events.

One unique tradition observed in Dedham and dozens of other New England communities for many years was the annual Parade of Antiques and Horribles. This parade originated in the mid-nineteenth century as a spoof of the Ancient and Honorable Artillery Company of Boston, a military honor guard that for many years has held a ceremony and parade in Boston on Independence Day. A mock procession of ragamuffin youths and elders dressed in outlandish outfits was the perfect way to lampoon the grandiose annual spectacle. Over time, the Parade of Antiques and Horribles evolved into a more general costume parade, with floats and marchers often satirizing current political and social figures and events. A 1907 *Transcript* article describes a Horribles parade that "gave the jokesmiths a grand opportunity to work off superfluous wit." Included in that year's display were celebrants portraying Siamese twins, the wild man of Borneo, a bearded lady, a "nondescript what is it—man or woman—a nickel a guess" and the bicycle navy. Marchers portraying Hitler and Mussolini were greeted with boos and catcalls as they made their way along the route in the 1943 parade. The tradition continued in Dedham until the 1950s, after which more formal entries such as marching bands and children's television star Rex Trailer were featured.

From the beginning, the observance of American independence has always been associated with NOISE! American cities and towns greeted the holiday in the early hours of dawn with cannon blasts and the pealing of bells, while cherry bombs and firecrackers punctuated celebrations throughout the day and into the night. Fireworks were readily available in every community, and revelers both young and old delighted in setting the punk to the fuse that lit the backyard sky with ladyfingers, Roman candles, torpedoes, rainbow wheels and a host of other fireworks.

But with every year's celebrations came stories of drunkenness, rowdyism, devastating injuries and even death caused by fireworks. The early twentieth century brought about calls for toning down the out-of-control celebrations. In 1909, the Safe and Sane 4th Campaign, sponsored by the Playground Association of America, began, with President William Howard Taft serving as its honorary chairman. Fireworks bans were put into effect and towns were encouraged to offer fun and safe holiday events. Dedham did its part to keep its citizens free from injury, sponsoring a variety of activities aimed at controlling the revelry. A list of Fourth of July "Don'ts" published in the *Dedham Transcript* in 1908 gives both real and tongue-in-cheek advice to celebrants, including these:

Don't encourage small boys to fire large cannon.
Don't throw firecrackers at passing bicyclists.
Don't aim a sky rocket at an upstairs window.
Don't put firecrackers on the steps of a church.
Don't put firecrackers under old ladies' dresses.

At about the same time that the Safe and Sane campaign was taking hold across the country, a Fourth of July tradition began in Dedham that was decidedly unsafe, and maybe even a little insane. As early as the 1880s, sure-footed youths had made a game of climbing the tower of the Church of the Good Shepherd at the corner of Cedar Street and Cobbler Lane and ringing the bell to welcome in the Glorious Fourth. Beginning sometime early in the twentieth century, the bell ringing signaled the start of one of the most popular holiday events in Dedham history—the burning of the wagons in Oakdale Square. After liberating old horse-drawn wagons from wherever they could be found around town, revelers would haul them to the center of Oakdale Square on the night before and set them ablaze as hundreds of onlookers cheered. In the early years of the burnings, police and fire officials gave tacit permission for the bonfires, their presence in the square merely ensuring the safety of the spectators. Flames from the wagons shot high into the air, and the intense heat would often crack the windows of local businesses. As morning arrived and the fires finally died down, firefighters would douse the embers and the cleanup would begin.

As the farms and barns in Dedham disappeared, so did the supply of wagons to burn. Teens began stealing wagons from more rural towns such as Medfield and Sharon and hiding them in backyards and garages until the holiday. In 1938, the bonfire consisted of nothing but an old WPA outhouse after police stopped a group of boys on their way to the square with a wagon stolen from Canton. Eventually, all of the wagons were homemade, sometimes utilizing decorative wooden wheels taken from local gardens.

A 1922 *Transcript* article contains the earliest reference to the wagon burnings in Oakdale Square; the last one took place in 1963. The celebration that year was an especially rowdy one. After the parade and fireworks, thousands gathered in Oakdale Square for the annual fiery fun. When firefighters and police arrived on the scene, they were met with flying stones, cherry bombs and full cans of beer. One of the rowdies jumped into a fire engine and turned off the ignition, hampering the efforts of the firefighters. He was arrested and charged with tampering with a fire apparatus. Fire Chief John Hartnett and Police Chief Walter Carroll were disgusted by the

Oakdale Square in 1946. *Dedham Public Library.*

whole affair, declaring that the once quaint tradition had finally gotten out of control and needed to be stopped. Chief Carroll vowed that this would be the last wagon burning. The following year, bad weather kept the crowds at home, and the year after that Oakdale Square was blocked to all traffic on both the night before and the night of the Fourth.

Eventually, the burnings moved to the Manor section of town, where things finally got out of hand in 1990. When a propane-soaked woodpile in a camper trailer exploded, it ignited the vinyl siding of a nearby house. Police Chief Dennis Teehan was determined to put an end to the dangerous tradition once and for all. The next year, a block party was held in MacDonald Square and hundreds of residents attended. Although a few

die-hards attempted to burn a wagon or two over the next few years, the unique tradition was over, and residents would have to find new, safer ways to celebrate our country's independence.

Heroes

The memorials to Dedham's war veterans are scattered throughout the town in parks and cemeteries and at small, landscaped street corners. Some tributes can even be found in various parts of the globe. These markers only hint at the heroism of Dedham's soldiers and sailors in the many wars against our nation's enemies. The following tales add a little more to that narrative.

The Liberty Pole. *Collection of James V. Horrigan.*

The oldest monument in town was erected in 1766 to honor an unlikely American hero. The Pillar of Liberty was placed on the First Church green at the corner of Court and High Streets by the Sons of Liberty to celebrate the repeal of the hated Stamp Act and the British statesman who helped to bring about its repeal, William Pitt. The pillar is long gone, but the stone base survives, with its original Latin and English inscriptions composed by Nathaniel Ames III. The pillar was carved from wood, stood sixteen feet tall and was topped with a carving of Pitt's likeness. Similar pillars were erected in New York and Boston. It was knocked down in May 1769 after Parliament continued to

106

Marker at the corner of Marsh and Court Streets commemorating the encampment of French troops during the Revolution. *Photo by author.*

impose new and unfavorable taxes. A reward of twelve dollars was offered by Samuel Doggett for any information concerning the destruction of the pillar. It has been told that Pitt's head was used as a football for many years by local youths.

A tablet commemorating an encampment of French soldiers during the Revolution stands at the corner of Court and Marsh Streets. Over 1,800 soldiers camped in the area from December 2 to 5, 1782, on their way to battle in Yorktown.

Dedham in the Rebellion

Over six hundred Dedham men and boys served in the conflict called "the Rebellion" by contemporaries and known as the Civil War by later generations. Most of Dedham's soldiers had the unique experience of training for battle just a few miles from home in Readville, which was part of Dedham until 1868. On April 19, 1861, one week after Fort Sumter had

Company E, Forty-fourth Massachusetts Infantry, at Camp Meigs in 1862. *Author's collection.*

been taken by the Rebel army, the Sixth Massachusetts Regiment arrived in Baltimore, on its way to answer President Lincoln's call to defend the nation's capital. Although Maryland had not seceded from the Union, a large and angry pro-Confederate crowd greeted the Massachusetts volunteers as they entered the city. Within a short time, the mob turned violent, and when it was over, four soldiers from Lawrence and Lowell lay dead, the first Union casualties of the war. That very night, a large crowd gathered in Temperance Hall in Dedham, where Abraham Lincoln had spoken thirteen years earlier. After listening to a series of patriotic and inspirational speeches, a number of Dedham men signed the roll to enlist in Dedham's first company.

The company trained on the grounds of the Norfolk Agricultural Society, which were located near the Dedham Common. On July 6, Company H set out for Readville under the command of West Point graduate Captain Henry Onion. The procession was led by a brass band and joined by members of the town's fire company, along with dozens of supportive citizens. The entourage marched three miles to the Dedham lower plain, where two training facilities called Camp Brigham and Camp Massasoit had been established alongside Sprague Pond. Eventually, the two camps were combined under one name, Camp Meigs, named for Montgomery Meigs, quartermaster general of the United States Army. The 125-acre camp spread from Sprague Pond to the Neponset River and was bisected by the Dedham-Providence Railway line. Over twenty-five thousand soldiers were trained here, consisting of eight artillery battalions, four cavalry regiments and fourteen infantry regiments.

The most famous of these regiments was the Fifty-fourth Massachusetts, the first authorized all-black regiment to fight in the war. The regiment was formed at the urging of Massachusetts governor John A. Andrew after

Monument in Village Avenue graveyard to soldiers who died at Readville. *Photo by author.*

Lincoln's Emancipation Proclamation in January 1863. Recruiters scoured the country for volunteers, who began arriving in Readville in February 1863. While the formation of this regiment was a milestone in civil rights history, abolitionists including Frederick Douglass, whose own two sons were in the regiment, were disappointed when white officers were assigned to lead the soldiers. West Roxbury native Robert Gould Shaw was appointed commander, with Dedham's own William Simkins serving as one of his captains.

On May 18, a grand review of the regiment was held on the parade grounds at Camp Meigs. Over 1,000 spectators, including abolitionist leaders Frederick Douglass, William Lloyd Garrison and Wendell Phillips, watched as Governor Andrew presented the regimental colors. That night, a grand ball was held for the Fifty-fourth at the Norfolk Hotel. The regiment departed by train for South Carolina on May 28. For the next month and a half, the soldiers saw little action, but that changed on the afternoon of July 16, when a skirmish with Rebel forces resulted in 42 Union casualties. Two days later, on July 18, the Fifty-fourth led an attack on Fort Wagner, where their valor earned them a place in history. Colonel Shaw and Captain Simkins, along with 156 of their men, were killed in the battle. Colonel Shaw and his men were honored with a monument on the Boston Common in 1897. The story of the regiment was told in the 1989 Academy Award–winning film *Glory*.

Camp Meigs became a hospital camp later in the war, and hundreds of wounded soldiers arrived there by train from battlefields across the South. Sixty-four soldiers who died at the camp are buried in the Village Avenue cemetery under a large granite monument topped with a pyramid of cannonballs. In 1868, the Readville section of Dedham, encompassing some 866 acres, was combined with sections of Dorchester and Milton to create the town of Hyde Park, which itself became part of the city of Boston in 1912.

A Navy Contraband

An obituary appearing in the *Boston Globe* on May 24, 1923, describes the accomplishments of eighty-six-year-old William Gould of Dedham, including command of the local GAR (Grand Army of the Republic) post and his service on the Union ships *Cambridge*, *Ohio* and *Niagara*. The notice states that Mr. Gould enlisted in the navy in 1863, which, while

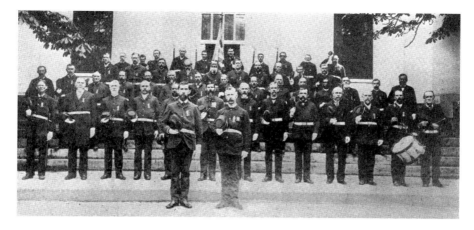

Members of the Charles W. Carroll GAR (Grand Army of the Republic) Post in 1886. William Gould is in the second row, fifth from the left. *Author's collection.*

true, does not tell the complete story. What is not stated is that Mr. Gould was born a slave in North Carolina and *escaped* to the navy in a daring move with seven other slaves.

On the night of September 21, 1862, twenty-four-year-old Gould and seven other slaves set their plan into action. After darkness had descended, the men boarded a small boat in Wilmington, North Carolina, and began rowing south on the Cape Fear River, heading for the open sea. If they could manage to maneuver their boat downriver twenty-eight miles, slip past the Confederate-held Fort Caswell and get picked up by a Union ship, they would gain their freedom. Such escaped slaves were considered "contraband" of war, property seized by the Union forces.

Gould and his mates reached the Atlantic Ocean in the early hours of September 22 and hoisted their sail. They were soon spotted by crew members of the USS *Cambridge* and taken aboard. A few days later, they took an oath of service and became official members of the United States Navy.

William Gould was no ordinary sailor, as evidenced by the diary he kept throughout most of his naval service. Amidst the passages describing the routine life of a sailor are found passionate and eloquent arguments against slavery and the Southern way of life. Gould served until the end of the war and eventually made his way to Dedham in 1871, where he and his wife raised a large family on Milton Street.

Gould was a master plasterer, and in the 1880s he was awarded a contract to do the interiors of St. Mary's Church on High Street. He was a respected and honored citizen of the town, serving as commander of the local Grand

Army of the Republic post, writing for various publications and helping establish Oakdale's Church of the Good Shepherd. In the late 1950s, William Gould III discovered his grandfather's diary while cleaning out the family home on Milton Street. His son, Stanford University professor William Gould IV, edited and published the diary in 2002.

Memorial Hall

Before the fighting had even ended in the spring of 1865, the citizens of Dedham had begun considering the most appropriate way to commemorate the bravery of its men and boys who had died to preserve the Union. As the topic was being discussed throughout the town, an idea took hold that would allow the town to address two problems at once—the need for a new town hall and the desire to honor the forty-seven "sons of Dedham" who had died in the Rebellion. At town meeting in May 1866, it was decided that a new town building, to be called Memorial Hall, would be built at the corner of Centre (now Washington) and High Streets. The design called for an imposing stone structure modeled after ancient English guild halls, built of Dedham granite with a central tower of eighty-five feet.

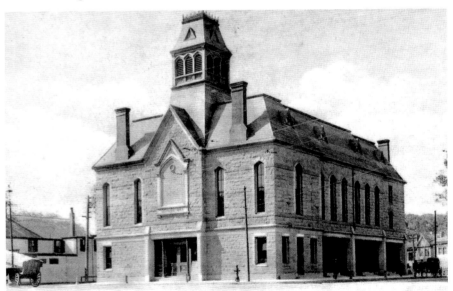

Memorial Hall. *Author's collection.*

Construction took two years, and Memorial Hall was dedicated in an elaborate ceremony on September 28, 1868. A large memorial tablet of Quincy granite was placed above the hall's entrance, with additional tablets bearing the names of the fallen located inside the vestibule. Along with town offices, Memorial Hall housed the post office, several first-floor retail establishments and a second-floor auditorium that could hold one thousand people. For many years, this auditorium was the only large indoor gathering space in town, and a variety of events took place there, including minstrel shows, concerts, lectures, plays and movies.

At the dedication ceremony, historian Erastus Worthington remarked in his address, "Let this our Memorial Hall receive a benediction from us all today, God keep it ever from the lightning strike and the consuming fire." He should have added the wrecker's ball to his list, as the building was taken down in 1962. Town employees had long been advocating for updated, modern offices, having been forced to work while wearing coats in winter and dodging rainwater leaking through the ceilings in spring and summer. In 1955, the building's ornate tower was found to be unsafe and was taken down. The front door of Memorial Hall was shut and locked by town clerk John Carey for the final time on March 16, 1962. The marble memorial tablets were moved to the lobby of the new town hall on Bryant Street. The building was demolished in April, and a new police station was built on the Washington Street site.

The Great War

One of the first American casualties of World War I was Dedham resident Henry Farnsworth, who joined the French Foreign Legion in January 1915 and was killed in action in October near Tubure, France. An elaborate monument to Farnsworth stands in Souain on the Marne in France. Another early American casualty was Robert Bayard, who is memorialized on a boulder in the Riverdale schoolyard, along with fellow Pine Heights boys Charles Clough and Stanley Luke. Memorial Park was formed from twenty-three acres of town-owned marshland bordered by East Street and Eastern Avenue and dedicated to the bravery and patriotism of the Dedham soldiers killed in the war.

Across from the park, on the corner of Whiting Avenue and East Street, a stone monument was dedicated on May 17, 1931. Shortly after the ceremony, Reverend George O'Connor, pastor of St. Mary's Church, mentioned a

The World War I memorial with its corrected inscription. *Photo by author.*

concern that he had about the translation of the Latin inscription *Pax Victus*, which was carved at the top of the monument. Rumors about the priest's concerns persisted for a few years until the spring of 1936, when the monument needed repairs. American Legion commander Hamilton decided to confirm

the rumor once and for all, and after checking with several authorities, he learned the uncomfortable truth—the Latin inscription *Pax Victus* actually translates into the English phrase "Peace to the Vanquished." After the issue was brought up at town meeting, it wasn't long before national newspapers and radio shows were relating the story of the small New England town that had unwittingly erected a monument to the defeated Germans. At town meeting, $400 was appropriated to change the inscription to read *Pax Victoribus*, or "Peace to the Victors." In the end, the monument was altered to simply read *Pax*.

Captain John Hayes was a Dedham native who distinguished himself as an Air Force pilot in World War II by earning a Bronze Star and a Distinguished Flying Cross. In 1954, he was stationed at the U.S. Camp McCauley in Salzburg, Austria. At the request of an Austrian doctor, Hayes began taking local children on high-altitude flights in an effort to relieve some of their pain and discomfort caused by whooping cough. Hayes made over one hundred such flights and was soon known as "Whooping Cough Captain." On December 28, 1954, his single-engine plane crashed, killing him and a crew member. The efforts of the young pilot were so appreciated by local Austrian officials that a nine-foot granite obelisk was erected to his memory near the airfield where he was stationed. Captain Hayes was buried in Brookdale Cemetery in February 1955.

Beyond the Call of Duty

John A. Barnes III grew up in the Greenlodge section of Dedham and graduated from Dedham High School in 1964. After graduating, he enlisted in the army and trained at Fort Benning, Georgia, before serving a one-year tour of duty in Vietnam, where he was awarded the Bronze Star, the Purple Heart and several other medals for valor.

Barnes began a second tour of duty in the fall of 1967 in the active central highlands of Vietnam, where he was a grenadier with the 503rd Infantry. On November 19, Barnes and his unit came under attack by a battalion of North Vietnamese. When an American machine gun crew was killed, Barnes quickly manned the gun himself, killing nine enemy soldiers while under heavy attack. As he paused to reload, Private Barnes saw a hand grenade land directly in the midst of a group of wounded

Private John A. Barnes Memorial. *Photo by author.*

Americans. In an act of extreme bravery and selflessness, Barnes threw himself on the grenade just before it exploded, saving his fellow soldiers.

Private Barnes was laid to rest in Brookdale Cemetery, and two years later he was posthumously awarded the highest military decoration, the Congressional Medal of Honor. A portion of the citation accompanying the medal reads: "Pfc. Barnes' extraordinary heroism, and intrepidity at

the cost of his life, above and beyond the call of duty, are in the highest traditions of military service and reflect great credit upon himself, his unit, and the U.S. Army."

On April 19, 1970, Memorial Field was rededicated as John A. Barnes III Memorial Park. An impressive gathering of dignitaries, VFW members from dozens of towns and local marching bands processed to the corner of East Street and Eastern Avenue, where a marble monument was unveiled. Congressman James A. Burke was one of several speakers who spoke of Barnes's heroism.

Conclusion

It is natural to lament the passing of so many traditions, especially those that make a town unique and bring its citizens together in celebration. But the spirit of those traditions lives on in more recently established community events, such as the Flag Day parade, Dedham Day celebration and the James Joyce Ramble road race. And the thriving Dedham Square district is the envy of many a neighboring town, with its collection of restaurants and shops and old-fashioned movie theatre, which has been in operation for over eighty years. One thing is certain: telling the tales of Dedham's heroes and villains and its bygone customs and places is one way to inspire new generations to continue time-honored traditions and perhaps renew forgotten ones. Who knows? Maybe on some sunny Fourth of July in the not too distant future, the streets, skies and waterways of Dedham will once again be filled with the sights and sounds of fireworks, canoe races, bonfires and a children's parade of Horribles, bringing smiles to those who remember when.

BIBLIOGRAPHY

Alcott, Louisa May. *Short Stories*. Mineola, NY: Dover Publications, 1996.

Animal Rescue League of Boston Annual Reports, 1899–1908.

Arkins, Dianne C. *The Glorious Fourth of July: Old-fashioned Treats and Treasures from America's Past*. Gretna, LA: Pelican Publishing Company, 2009.

Austin, Walter. *Tale of a Dedham Tavern*. Cambridge, MA: Riverside Press, 1912.

Bernhardt, Winfred E.A. *Fisher Ames, Federalist and Statesman, 1758–1808*. Chapel Hill: University of North Carolina Press, 1965.

Briggs, Samuel. *The Essays, Humor, and Poems of Nathaniel Ames, Father and Son of Dedham, Massachusetts, from their Almanacks, 1726–1775*. Cleveland, OH: Short and Forman, 1891.

Cummings, Abbott Lowell. *The Fairbanks House: A History of the Oldest Timber-Frame Building in New England*. Boston: Fairbanks Family in America and New England Historic Genealogical Society, 2002.

Dedham Historical Society. *Dedham Historical Registers* 1–14. Dedham, MA: Dedham Transcript Press, 1890–1903.

———. *Images of America: Dedham*. Charleston, SC: Arcadia Publishing, 2001.

Dedham Transcript Tercentenary Edition, September 1936.

Fischer, David Hackett. *Liberty and Freedom: A Visual History of America's Founding Ideas*. Oxford, England: Oxford University Press, 2004.

Fitch, Jabez. "Diary of Jabez Fitch." *Proceedings of the Massachusetts Historical Society* 9 (1894): 40–91.

Forbes, Alan. *Taverns and Stagecoaches of New England*. Boston: State Street Trust Company, 1953.

Gould, William B., IV. *Diary of a Contraband: The Civil War Passage of a Black Sailor*. Stanford, CA: Stanford University Press, 2002.

Hanson, Robert Brand. *Dedham Massachusetts, 1635–1890*. Dedham, MA: Dedham Historical Society, 1976.

———, ed. *The Diary of Dr. Nathaniel Ames of Dedham, Massachusetts, 1758–1822*. Camden, ME: Picton Press, 1998.

Harding, Walter. "Thoreau's Feminine Foe." *Proceedings of the Modern Language Association* 69 (March 1954): 110–16.

Hill, Don Gleason, ed. *The Record of Baptisms, Marriages and Deaths in the town of Dedham, Massachusetts, 1638–1845*. Dedham, MA: Dedham Transcript, 1888.

Hurd, Duane Hamilton. *History of Norfolk County, Massachusetts: With Biographical Sketches of Many of Its Pioneers and Prominent Men*. Philadelphia, PA: J.S. Lewis & Co., 1884.

Hyde Park Historical Society. "The Striped Pig." *Hyde Park Historical Register* 8, no. 1 (April 1892): 44–53.

Mann, Herman. *Historical Annals of the Town of Dedham, From its Settlement in 1635 to 1847*. Dedham, MA: 1847.

Matteson, John. *Eden's Outcasts, the Story of Louisa May Alcott and Her Father*. New York: W.W. Norton, 2008.

Pletcher, Larry. *It Happened in Massachusetts*. Guilford, CT: Globe Pequot Press, 1999.

Rogers, Alan. *Murder and the Death Penalty in Massachusetts*. Amherst: University of Massachusetts Press, 2008.

Sherman, Paul. *Big Screen Boston, From Mystery Street to the Departed and Beyond*. Malden, MA: Black Bars Publishing, 2008.

St. George, Robert Blair. *Conversing by Signs, Poetics of Implication in Colonial New England Culture*. Chapel Hill: University of North Carolina Press, 1998.

Transcript Press. "Historic Dedham." 1920.

Walden, Jane Brevoort. *Igloo*. New York: G.P. Putnam's Sons, 1931.

Watson, Bruce. *Sacco and Vanzetti: The Men, the Murders and the Judgment of All Mankind*. New York: Viking, 2007.

INDEX

ABOUT THE AUTHOR

James L. Parr grew up on Tower Street in Dedham and attended St. Mary's School, Dedham High School and Bridgewater State College. In 1998, he founded the children's drama group HAAM (Hilarious Acting Around Massachusetts) in Dedham, and has written and directed over a dozen plays, raising funds for such organizations as the American Diabetes Association, the Jimmy Fund, the MS Society, the Fairbanks House and the Dedham Council on Aging. He also created Haunted Halloween Trolley Tours in both Dedham and Framingham. Jim is a third-grade teacher at the McCarthy School in Framingham. He is the co-author with Kevin A. Swope of *Framingham Legends and Lore*, also published by The History Press.